The Ottoman Touch

MEHMET ZEKİ KUŞOĞLU

The Ottoman Touch

TRADITIONAL DECORATIVE ARTS AND CRAFTS

NEW JERSEY • LONDON • FRANKFURT • CAIRO

BLUE DOME

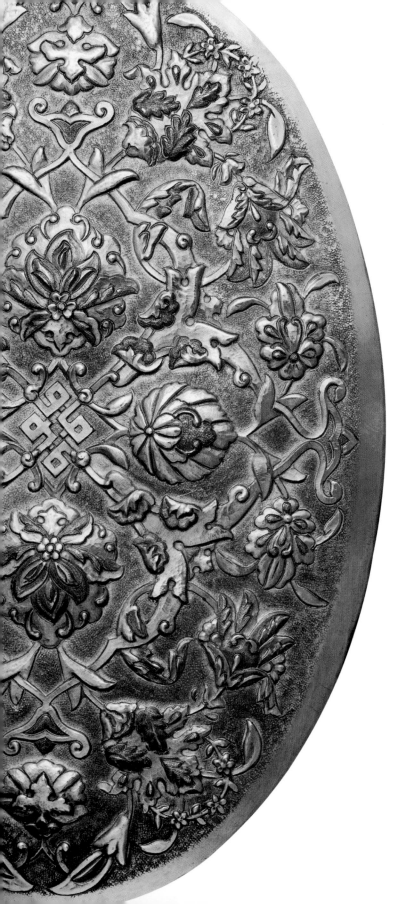

Published by Blue Dome Press
535 Fifth Avenue, Ste. 601
New York, NY 10017-8019

www.bluedomepress.com

Library of Congress Cataloging-in-Publication Data Available

ISBN: 978-1-935295-58-7

Printed by
Yazmat Matbaacılık ve Tanıtım Hizmetleri San. ve Tic.
Ltd. Şti. Davutpaşa Kışla Cd. Kale İş Merkezi B Blok
No:37/44 Zeytinburnu, İstanbul / 0212 483 22 77

ⓩ This symbol shows the author's own works of art.

Contents

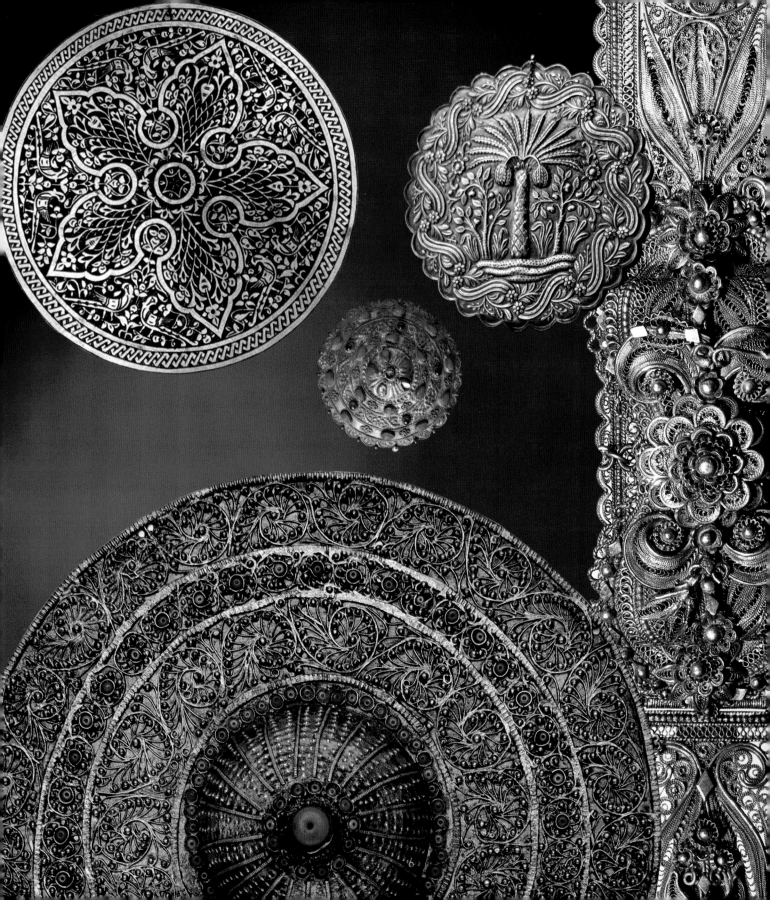

6

Foreword

This book is a compilation of my articles. Each article was written after I found no satisfactory written source on each traditional art in Ottoman civilization. Unfortunately, the only written information I found on these arts was unverified encyclopedic data. Some of the names of the arts were even not determined.

There are multiple reasons for this lack of information:

• Learning our own traditional arts by reading the works of foreign writers, who are not qualified enough to speak knowledgeably about them.

• Unsatisfactory translations of the Turkish writers who have actually done adequate research on our traditional arts.

• Having no dictionary of arts in Turkey and thus being forced to use non-Turkish terms all the time.

• Referring too often to references, which were mostly written with the help of translations of secondary sources by our art historians and writers, who could not research the very works of art at hand.

• Superficial repetitions around common topics regarding Turkish arts.

• Unreliable books, full of photos with captions, that failed to examine the techniques and the philosophy of Turkish art.

Although I am not an art historian, these—and other—issues forced me to further investigate. I am aware that it is not fair to put the blame on just the researchers and art historians. The root problem is the inferiority complex we express, inherited since

Tanzimat, a period of reformation that began in 1839.

Consequently, Turkish arts, which are not known in the West, were just ignored, and sometimes even insulted. Research was not encouraged, and those who did research could not publish their works. After all, it was not possible to make a living as a researcher. What research was done was made in pretense, and sometimes with great fatigue.

When I began this project, I started by writing articles on the arts I was personally involved in during my childhood and youth. I left aside the great works, as these have actually been well covered. I thought that I should write about what has not been explored or correct the mistakes which had been made.
I hoped to confirm the words of the poet:
If the aim is a work of art, then an elegant verse is sufficient
I wonder much over Alexander's Rampart

Lâ Edri

While working on this, I have spent years visiting scrap dealers, silversmiths, coppersmiths, and mother-of-pearl workers. Scrap dealers are today's antique dealers. I have learned about art and the history of art in the shops of these scrap dealers.

Sadly, during my research, I must report that I have seen no Turkish academics in these places for years, though I have seen some foreign researchers. This is a shame, because the amount of art I discovered was incredible. I've seen so many gorgeous works that 3 or 4 new museums could be built solely to exhibit them. I touched them, caressed them, and loved them. I could not afford to buy the perfect ones, but managed to buy some of them with minor defects. I mended and regained them for our arts, and used them as samples in my articles.

As a nation, we made history but did not write it; we made art, but did not keep track of its history.

If we want to find our art history, it can be rewritten by finding this art has been left as if it were worthless, or by finding the pieces sold to foreign dealers, just as the Ottoman Archive was plundered or sold abroad. We must be resolute in our quest.

My hope with these articles and with the books I am in the process of writing is not just criticism; it is conversation. I hope that my friends, or even those who oppose me, will serve our arts by writing new books.

May Lord help us to thrive.

№ 698.

ntrée de la Mosq-Ahmed

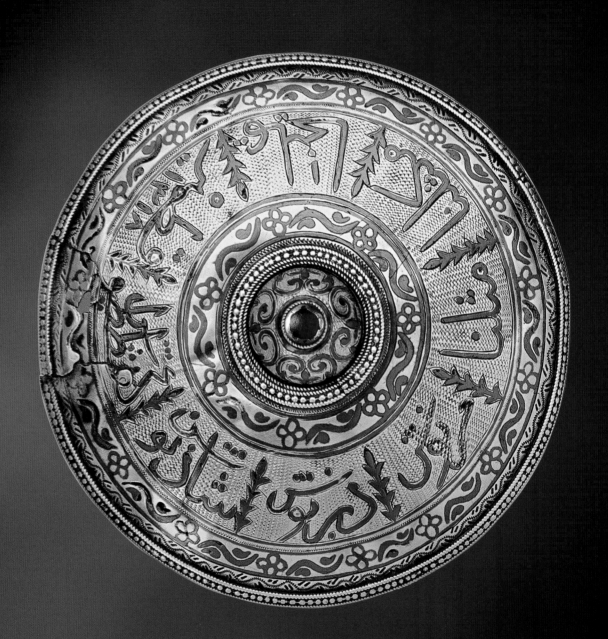

Savat
(Niello)

The modern Turkish word "savat" is derived from the Arabic word "sawad", meaning "blackness," "darkness," "engraving in black." The Turkish variation "sevad" is to be found in various combinations in Ottoman Turkish such as "sevad-i a'zam" (the city of Mecca), "sevadü'l-ayn" (pupil or apple of the eye), "sevadü'l kalp" (the black spot that is supposed to exist in the center of the heart).

It is now used only in connection with a type of engraving producing an effect of black lines on silver. Although *savat* resembles the Western art of engraving it is actually a much more difficult process. Whereas engraving is always applied to a flat surface, *savat* is applied to all types of geometric forms.

As an art of engraving *savat* is carried out in two stages:

1) *kalemkarlık*, the actual engraving

2) the preparation and application of the materials.

Kalemkarlık: The most essential part of the work is the process of engraving. But it should not be forgotten that this is preceded by work carried out by a number of other craftsmen. In other words, before the engraving begins, the material must be beaten and wrought into shape. Once the amulet or tobacco box whatever has been produced by the silversmiths, the engraver will examine it carefully and consider what type of decoration would be most suitable. He then takes a piece of paper and begins to experiment with various possible designs until he finds the one he prefers. Some craftsmen, instead of using pen and paper, prefer to trace the design directly on the silver with a lead or indelible pencil.

As *savat* can be applied only to completed forms it is impossible to apply the *savat* first and then shape the object afterwards.

The design, whether it is a landscape, a coat-of-arms, an inscription, a flower composition or the like, is either traced on to the object or drawn on it directly in pencil, after which the lines are engraved using a steel pen.

Belt with *savat* work from Van province. ▶

11

Front and rear side of a tobacco box with *savat* work from Van province.

Here I should like to dwell for a moment on the training required to produce a skilled *savat* craftsman. The apprentice, who must, of course, have a talent for drawing and design, begins under the supervision of a master craftsman by engraving simple forms in cheap materials such as copper or brass. Engraving is an art that requires constant practice. If there is no actual work to be undertaken the apprentices keep their hands in by working on anything available.

In the old days the apprentices never asked for any pay from their master while they were learning their trade. As a matter of fact the poorer apprentices would sometimes practice on the copper rings around the columns in the mosque courtyards, and even today it is still possible to see traces of the designs engraved by these apprentices. Talent, hard work and determination were essential ingredients of the work we see today. As the saying goes, "With patience and determination you can make satin out of a mulberry leaf."

The craftsman produced by this combination of talent, skill and patience fine specimens of engraving. Holding his breath' and using the strength of his wrist and sharp 'v'-shaped steel pen, he engraves in the metal the designs he has created and traced upon its surface, sometimes maneuvering the work itself, sometimes moving the steel pen.

Two different types of engraving are employed:

I. The fine Van engraving

2. The deeper Caucasian engraving

As their names suggest, these two schools of engraving are named after the region in which the finest work of each particular type was produced. Fine engraving is employed in very delicate work, while the deeper engraving is used in simpler and sturdier objects. In any case, the style is more or less dictated by the character of the object itself. Horse harness, Caucasian

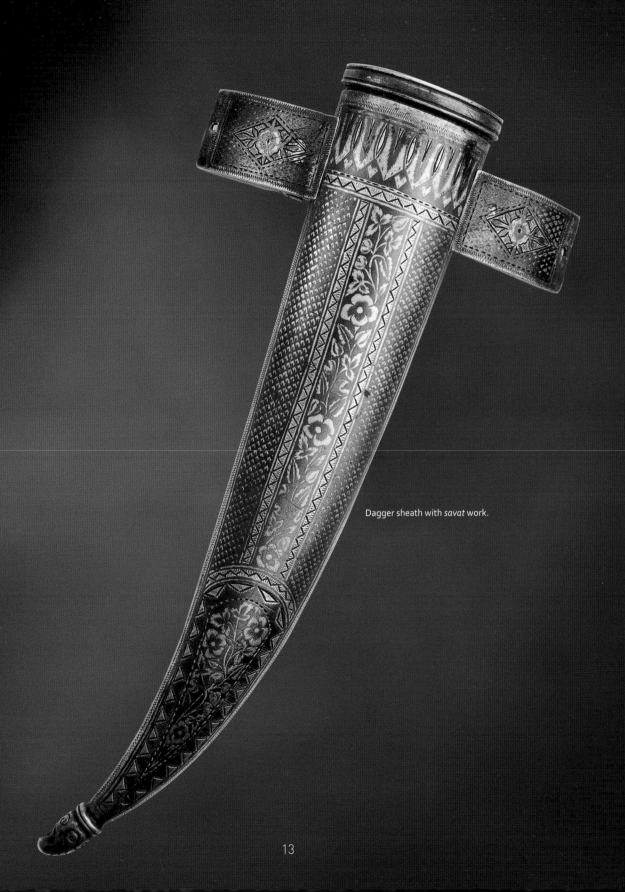

Dagger sheath with *savat* work.

Vase with *savat* work from Van province, designed for European market.

saddles, powder horns, dagger sheaths and handles are decorated with Circassian engraving, while Van engraving is used for tobacco boxes, cup holders, cigarette holders, whips, etc.

For the preparation of the materials to be used in *savat* one requires:

a) I measure of silver.

b) 4 measures of copper.

c) 4 measures of lead.

d) A sufficient amount of sulphur.

The silver and copper are first of all fused together in a crucible. The four measures of lead are then added to the molten mixture after which the sulphur is slowly added until it assumes a dark grey color. This mixture, known as *savat*, is then emptied out into a pot and left to cool.

Once the mixture has cooled and hardened, it is beaten on a piece of iron into small pieces and then put in an iron mortar and pounded to powder.

After this has been passed through muslin or a fine sieve, it is ready to use. According to the type of work to which it is to be applied and the personal preferences of the craftsman, the *savat* can be used in the form of powder (*ekme savat*) or mixed with borax to form a sort of paste. This *sürme savat* is used in filling the empty spaces.

The *savat* is either sprinkled or pressed into the grooves opened by the steel pen, after which the work then heated in order to melt the *savat* and ensure that the grooves are properly filled. Once the *savat* has cooled and fused completely with the work to which it has been applied, the surface is levelled using very fine files and sandpaper. The work is then polished and placed in the shop window or handed over to the customer who had ordered it.

Savat work in high quality silver is of quite exceptional beauty. From the

large number of objects that still survive it would appear that at one time it was felt to be absolutely imperative for everyone to own at least one example of *savat* work. The most common types of objects to be decorated in this way were tobacco boxes, whip handles, belts, headdresses, powder horns, trays, charms and amulets.

Savat work was once very popular in Europe, particularly before the First World War, and large quantities were exported to France.

In Van, before the First World War, there were nearly four hundred *savat* craftsmen working in one hundred and twenty shops. Very fine *savat* was produced in the provinces of Bitlis, Sivas, Erzincan, Eskişehir, Kula, Trabzon and Samsun.

The earliest center for this very beautiful and delicate work was in Dagestan, where *savat* is still produced in the age-old tradition preserved by the local Turkish tribes. The rich coal and metal mines near the village of Kubaçi, in an area inhabited by the Kumuk Turks, made the center of *savat* production.

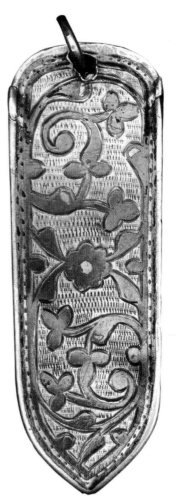

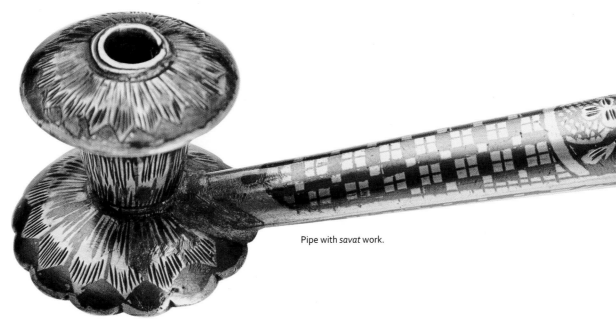

Pipe with *savat* work.

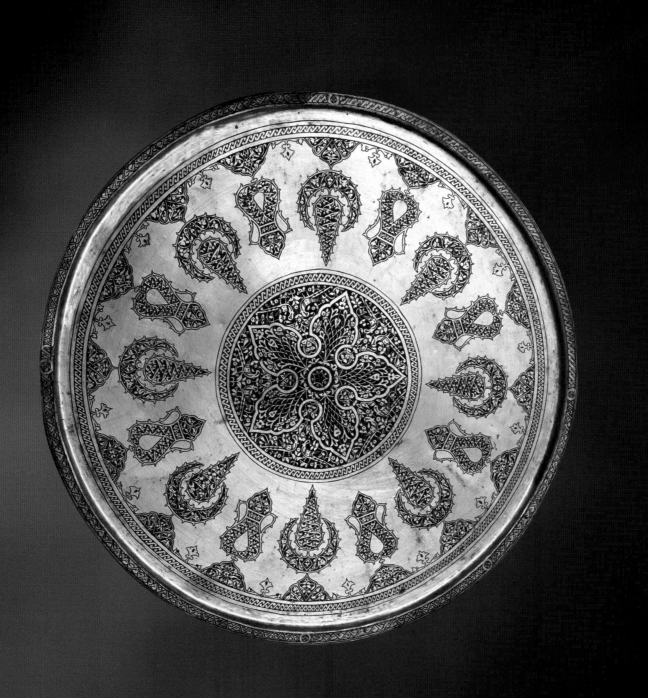

Kalem Work
(Engraving)

Kalem, in the modern sense of the word, refers to any instrument used for writing on paper—a "pen" in other words. But if we go back to the period before the invention of paper the word "kalem" was used to refer a metal instrument used for carving inscriptions on stone or terra cotta tablets.

With the invention of paper, *kalem* assumed a number of new forms and characteristics, but the first type of metal *kalem* was not abandoned, being developed for use in new fields. Thus *kalem* assumed the form and quality appropriate for the material on which it was to be employed, and was named accordingly (wood *kalem*, etc.)

We should here touch briefly on the place and function of *kalem* in Muslim thought. In the work entitled Gülzar-ı Savab (The Garden of Probity or the Garden of Holy Grace) the author, Nefes Zade İbrahim Effendi, refers to *kalem* in the following words:

"The eternal giver of praise and gratitude of all mankind, *kalem* belongs to God, the giver of grace.

Although God created *kalem* in the likeness of the cypress and the tree of Paradise, unlike other trees, its leaves are white, its blossoms black and its fruit lofty words.

Kalem is in love with God, but its inability to give adequate expression to its love submits it to constant weeping. It weeps unceasingly, with black blood flowing from its eye instead of tears.

Kalem is one of the keys to the grace of God, the means to all things, the basis of every type of solution.

As for the virtues of *kalem*, the Messenger of God, peace and blessings be upon him, declared: "God created the *Kalem* and gave the order 'Write!'"

Copper dish with Seljuk *kalem* work.

19

According to Ibn Abbas, one of the Companions of the Messenger of God, *kalem* was created of green emerald. Its length was a thousand years' journey. It was split by a beam of holy light.

Ibn al-Muqaffa refers to *kalem* in the following terms: "*Kalem* is the mounting-block for the intelligence of worthy and able men. *Kalem* is the declaration and expression of the human finger tips."

Before going on to *kalemkarlık* (engraving), it would be useful to touch briefly upon the various techniques included under this heading.

In weaving, *kalemkarlık* refers to the decoration applied by means of a brush to white cloth. (Here *kalem* is used to refer to a type of brush.)

In interior decoration, the term *kalemkarlık* means the painted decoration applied to walls, ceilings and domes. In stone-carving, *kalem* is the steel instrument, the chisel with a diamond point employed by workers in marble. All the works in marble we see around us were carved with this type of *kalem*. In wood-carving a *kalem* is an instrument with a wooden handle and a steel blade used for cutting into the wood to form a relief design. The type of "kalem work" or *kalemkarlık* we are dealing with here is the art of carving grooves in a flat surface using steel *kalem*s. Now let us examine this art in greater detail. The art of carving grooves in a relatively soft surface by means of a sharp-pointed instrument (usually made of steel) is as old as the history of mankind itself. Cuneiform writing is one of the earliest and most striking examples of this. The various stages in the struggle waged by *kalem* with its material range from primitive work in baked clay to carving in hard granite.

Although any struggle between hard and soft materials would appear to be destined to end with the submission of the softer, it was actually the softer materials that won the final victory. The proof of this lies in the fact that though *kalem*s have disappeared altogether, the work they created still survives.

The art of carving or engraving relatively soft materials such as gold, silver, copper or brass using *kalem*s with steel points is known as *kalemkarlık*, and the craftsman as a *kalemkar* (engraver). We should, however, point out here that silver is the most commonly used metal in this type of work. Gold is too expensive, and metals like copper and brass suffer too much

Pan cover with Bosnian *kalem* work.

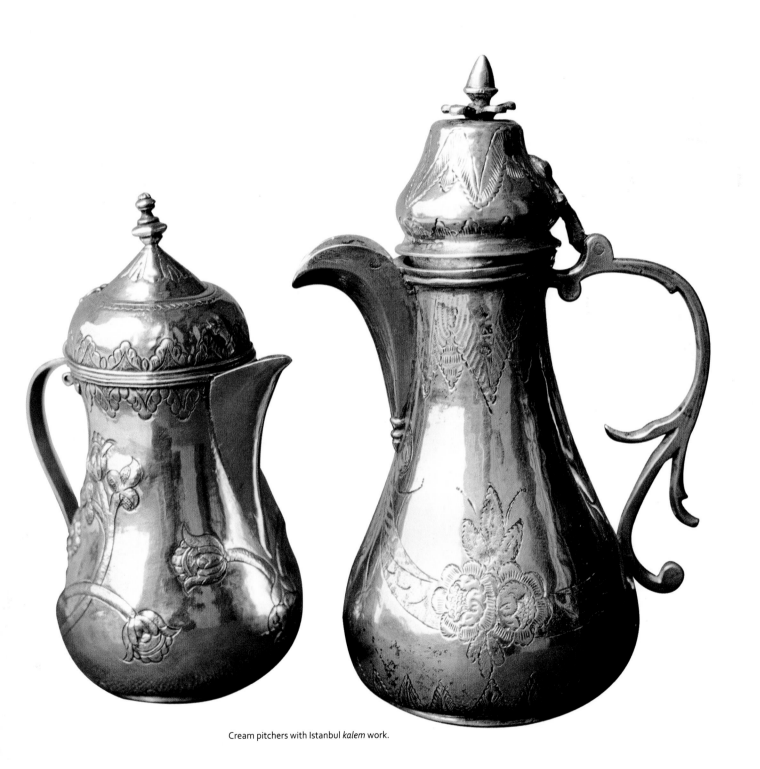

Cream pitchers with Istanbul *kalem* work.

from oxidization.

The most important tool used in this type of work is the steel *kalem* with various types of point. It was this type of *kalem* that was responsible for the creation of many of the works of art to be seen in museums and in our own homes.

"Kalem work" is carried out in the following manner: The craftsman first of all makes a draft sketch of the design to be applied to the silver ewer, tray, cup holder, etc. sent by the silversmith for decoration. If he is satisfied with the draft he transfers the design to the object using a single instrument, after which he will fill in the details of the design by means of various different types of *kalem*. The most important factor in all this is the skill of the craftsman's wrist. This is something that is practically impossible to describe in words. One must watch the craftsman actually at work. For example, in order to ensure a smooth curve, the craftsman will hold a *kalem* firmly in the palm of his hand and hold his breath while making the curve with a single swift stroke. In fine work, it is essential that the beginning and end of the curve should be executed with the same meticulous accuracy. The use of various different types of *kalems*, some deep-cutting, some more superficial, add greatly to the decorative quality of the work and make its appearance much more attractive.

Kalemkarlık is an extremely difficult art in which to attain a reasonable level of skill requires lots of time and dexterity. This explains why good *kalem* work is so rare and why there are so few really fine examples of the art. A master *kalemkar* may also learn the art of niello and become a master in this branch of art as well; or he may turn to hüsnühat (calligraphy) and become a master of seal-engraving. In other words, *kalemkarlık* might well be regarded as, at the same time, a stepping-stone to niello-work and seal-engraving, and in all these three arts the skill of the artist lies at the basis of the whole work. "Kalem work" can be employed either alone or in combination with other techniques.

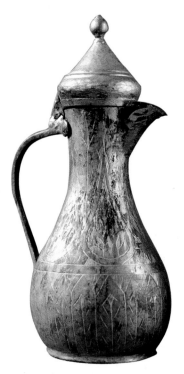

Coffee pot with Bosnian *kalem* work.

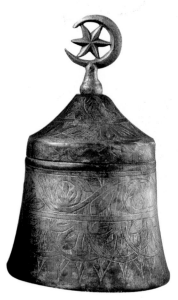

Cream pitcher with Bosnian *kalem* work.

A plate with Seljuk *kalem* work.

22

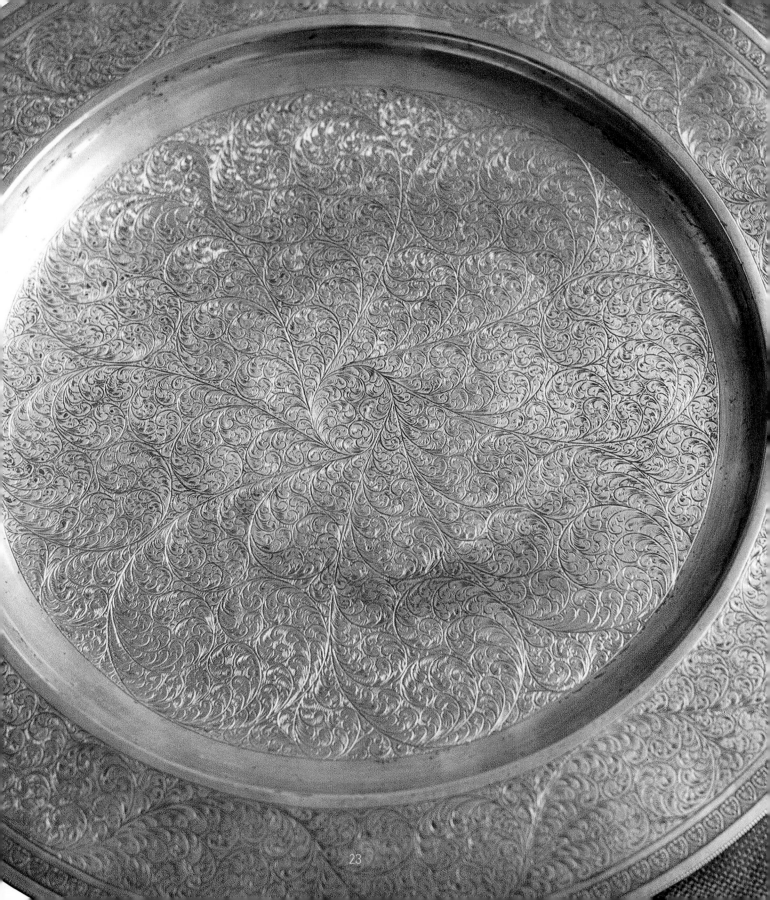

Silver Embossing

Embossing can be applied to all types of silver objects, whether for use or ornament, and consists of bossing up the silver from the reverse side by means of steel punches. Embossing is one of the very few arts to have survived from very early times to the present day with practically no change in the techniques employed.

This art has been practiced by all nations with their roots in the past, but the embossed work produced by each individual nation is distinguished by its own particular features. The form of the object and the techniques employed immediately reveal the place of origin.

It is very easy to decide to which nation any piece of embossing belongs without having to have the stamp examined by experts. Distinctive features of Turkish embossing are the depth of the relief and the simplicity and harmony of the design. These qualities distinguish it very clearly from Arabian, Persian or Indian work. At the present day, the art of embossing practiced mainly by nations which have not completed their industrial revolution.

The work to be embossed, whether a flat plate or some sort of receptacle, is first of all embedded in asphalt contained in a fairly large vessel. (This paste consists of a mixture of pine resin, a mortar of brick dust and lime, oil and asphalt.) Care must be taken to see that no pockets of air remain between the object and the asphalt, and the removal of any such pockets may be effected by heating. As for the reasons for using asphalt in this way: If a surface is punched out on a hard ground, this will produce conical depressions widening out from the point at which the surface is hit by the punch. The use of asphalt ensures that a depression in produced only at the point at which the punch actually contacts the metal while at the same time it also prevents any perforation. This method can be used even in the finest work.

After the work has been properly embedded in the asphalt, transfer paper with the design to be embossed is applied to the reverse side of the silver plate. The reason for its being applied to the reverse side is that it is from this side that the plate is to be bossed up. When the work is turned around the real design is revealed on the front.

Mirror with silver embossing.

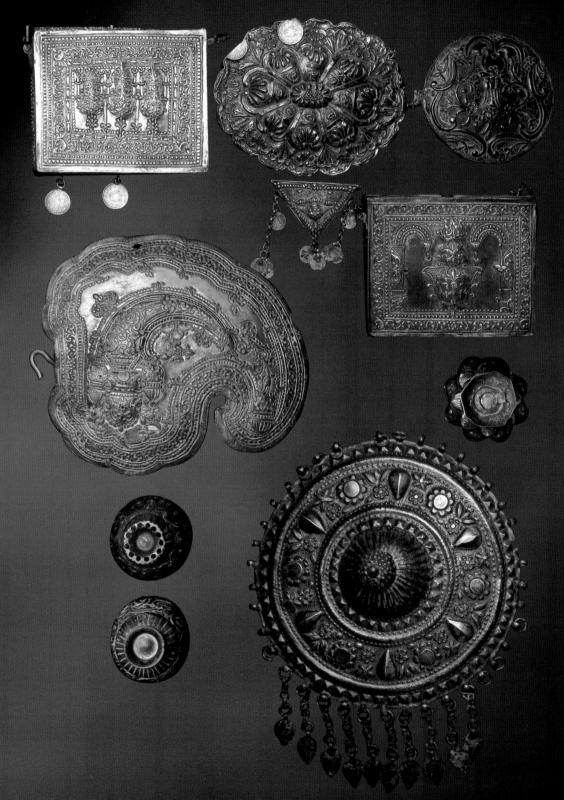

The design on the paper is transferred to the surface of the work in the form of a series of dots punched out by a sharp tool. In detailed work this may mean many millions of tiny dots. After the transfer is complete the actual work of embossing begins. Various different tools are employed for various phases of the work. In the course of the work the asphalt mixture will cool down, making work more difficult. This is countered by heating the object and the asphalt in which it is embedded by means of a blow-torch. Although the work is applied to the reverse of the plate, the aim is to produce relief on the front face. After this process is complete, the asphalt is removed from the surface by again heating it with the blow-lamp, this time to a much higher temperature until the silver is red hot. This not only separates the work from the asphalt, but also removes any particles of the asphalt which may still adhere to the surface of the silver.

Hamam bowl with Istanbul embossing.

When this is complete, the work is immersed in acid to remove any remaining particles and to clean the surface. The work is then re-embedded in the asphalt and left to cool. In order to avoid any errors we place the paper with the design in front of us. Again using steel punches, the front surface is hammered out in relief, special tools being used to define the contours of the design, and then the whole is polished with other tools. The final work is carried out by means of "sand tools."

These are of various types and produce variations in texture, the surface to which they are applied being given a matt appearance.

After this long and tiring process, the silver is again heated and removed from the asphalt. After which any of the processes may, if necessary, be repeated. Further work may be required, this depending entirely on the craftsman himself.

The tools employed in these processes are made by the craftsman himself in accordance with his own methods of work. All the various stages of the work that I have attempted to describe above must be carried out with the most scrupulous attention to detail. The crafts-man must be able to judge with the greatest precision the effect of every blow, even when these are applied to the reverse side of the plate, otherwise the work will have to be continu-ally retouched and amended, and whole processes repeated. At least several weeks' work is required to produce good quality work.

It is very encouraging to note that silver embossing has not, like so many of our traditional crafts, been partially or completely abandoned.

Ingredients for silver embossing.

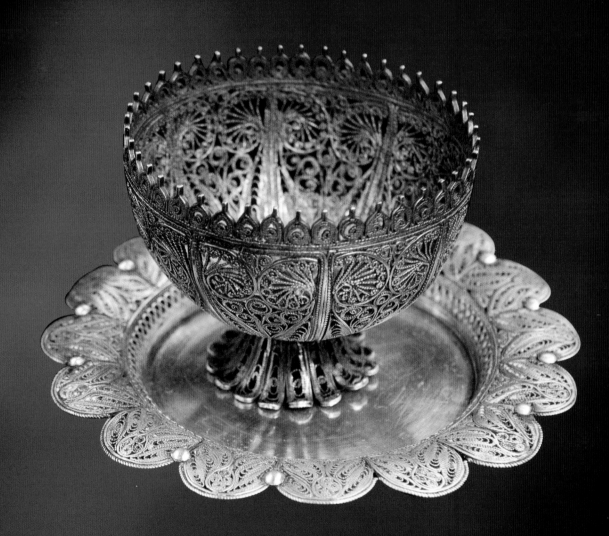

Telkari
(Filigree)

If the saying, "The Turks have made history but not written it," is true, then it is equally true that "The Turks have produced art but not a history of art." This is, however, entirely in accord with the beliefs and world outlook of the artists of former times. We Turks never felt the need to talk about or boast of what we did, and having once made a work of art and earned thereby our daily bread we were content to await our epitaph.

Westernization has done much to change our outlook in this respect, but instead of adopting the western system and writing our own history of art, we have been content with the translation of a few foreign books into Turkish.

This mistaken approach has not only resulted in our own artistic and cultural values and achievements being forgotten, ignored or even completely distorted, it also means that various branches of Turkish art that are still currently being practiced are, as a result of ignorance and indifference, being abandoned as old-fashioned and out of date.

Towards the middle of the present century, the rigidly uniform artistic outlook that had been dominant up to then began gradually to relax, and we began to turn our attention to our own traditional arts and to carry out research into their various branches. But those taking an interest in Turkish art, and folk art in particular, are deterred by the great variety of Turkish artistic productions, the fact that they have been neglected for centuries, by our lack of sufficient knowledge on the subject and the lack of encouragement given to research.

Before going on to our topic of *telkari*, let us take a brief glance at what has been written so far on the subject.

Telkari: Decoration made by applying silver in the form of wire to wood or other materials.

Ali Seydi: *Resimli Kamus-i Türki*, 1908, Istanbul, p. 303.

Telkari coffee cup holder.

Telkari cup holder.

29

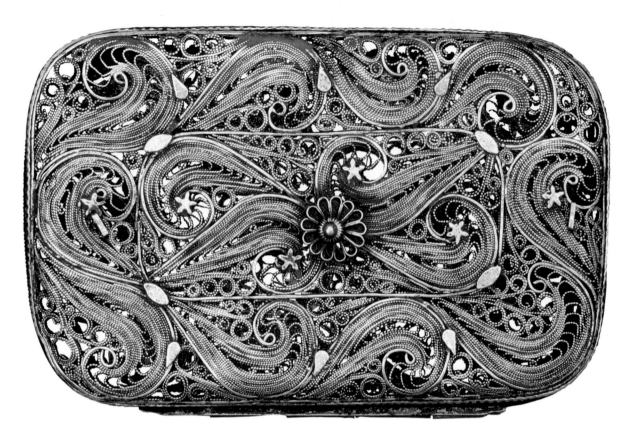

A highly skilled type of inlay decoration applied to wood and other materials using silver in the form of wire. *Telkari* walking-sticks, cigarette-holders, pistols.

Şemseddin Sami : *Kamus-i Türki*, 1900, Istanbul, p. 1317.

Compound word. Holders and similar objects made of gold or silver wire.

Hüseyin Kazım Kadri: *Türk Lügati*, 1927, Istanbul, p. 162.

Filigree made from silver wire or decoration made by applying it in the form of an inlay to other materials.

Ferit Devellioğlu: *Osmanlıca-Türkçe Ansiklopedik Lügat*, 1962, first edition, p. 1284.

Woven of gold or silver thread; stuff woven thus, filigree.

Redhouse, 1968, Istanbul, p. 1133.

Metal objects decorated with motifs produced by curving and twisting fairly thick gold or silver wire into the desired shape and then soldering them together. *Gömme telkari* is an inlay decoration achieved by inserting silver or lead wire into hollows cut in wood. *Les Arts Decoratif Turcs*, 1952, pp. 145–146.

Celâl Asad Arseven, *Türk Sanatı Ansiklopedisi*, 1943, first edition; 1975, fourth edition, Istanbul

Name given to objects made by joining and soldering together fine metal wires. A number of objects of this sort are made of silver. *Telkari* cup holders are particularly famous. The finest of these are made in Prizren.

Mehmet Zeki Pakalın: *Osmanlı Tarih Deyimleri Sözlüğü*, 1946, first edition; 1971, Istanbul, vol. 3, p. 450.

Telkari is a Persian word. Jewelry made by weaving fine gold or silver wire.

Meydan Larousse, 1973, Istanbul, vol. 12, p. 39.

Telkari (filigree) refers to the technique of creating patterns and motifs by bending and twisting gold or silver wire, and soldering these motifs together or applying them to a metal surface. *Telkari* is not a technique. In the Islamic period wire was made by drawing the metal through an aperture by means of pincers or some such instrument.

Dr. Ülker Erginsoy, *İslam Maden Sanatının Gelişmesi*, published by Ministry of Culture, 1978, Istanbul, pp. 37–38.

In *telkari* each part is firmly soldered together using pure silver powder. To make the solder the silver particles are first of all mixed with lead. If the craftsman is making, for example, a walking-stick he never uses a model. All this work is carried out at great speed.

Süleyman Özkan, art historian, "Filigran, Telkari", *İlgi*, Istanbul, 1984, p. 34.

Filigr'an (ital.) das, seit dem 3. Jahrt. vor Chr. nachweisbare Goldschmiedearbeit in der form kunstvoller Geflche aus feinem, rundem, geperltem öder gezwirntem Gold, Silver, Kupfer öder Eisendraht.

Der Volks Brockhaus; 1st ed. Leipzig, March 1931. 13th ed., Wiesbaden, May 1965.

Telkari: As the word itself implies, *telkari* is an art employing wire, but just as every game played with a ball is not football, so every art employing wire is not *telkari*. For example, the word *telkari* is not applied to the Trabzon type of bracelet, in spite of its being made from wire. Nor is it applied to the type of inlay in which wires are hammered into grooves opened in the wood.

Telkari is also known as *waw*-work. The name refers to the frequent use of a shape (the Ottoman letter "waw") in this type of work. It is also known as "çift" (pincers) work owing to the fact that the various pieces are brought together

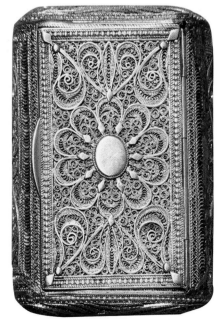

Telkari tobacco box.

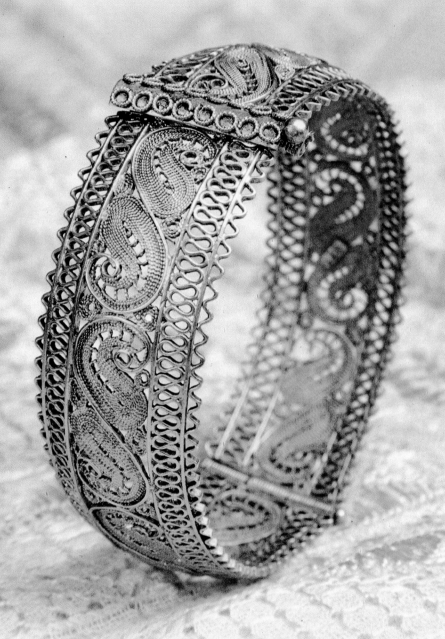

Telkari golden bracelet.

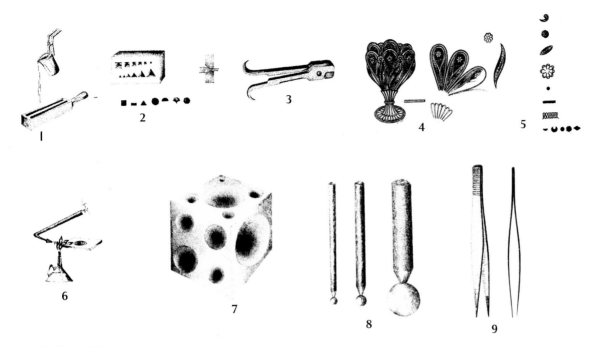

Tools for *Telkari*

1. Mold used for the production of rods. The upper face of the mold is used for the production of plates.

2. Above, steel wire-drawer's plate with, below, the various cross-sections of the wires drawn. (These are chosen according to the object to be manufactured).

3. Pliers with broad flat mouth used for drawing the wire.

4. The manufacture of a *telkari* cup holder: The sketch shows how each section is prepared separately.

5. Some of the various forms used in the manufacture of *telkari*.

6. Welding in the preparation of *telkari*.

7. Female mold (*haştek*) of metal or hard wood used in the production of three-dimensional *telkari* objects (such as cup holders).

8. Various types of male mauls: *hafşek*s.

9. As pincers are used for bringing the various parts of the *telkari* object together *telkari* is sometimes known as "pincer" work.

Telkari hand mirror.

by means of very fine pincers. These two means are normally employed by craftsmen.

As in a number of our traditional craft the materials to be used have generally, to be manufactured by the craftsmen themselves. In other words, the wire to be used in *telkari* has to be made from raw materials in the craftsman's own workshop.

We should therefore begin by describing how the wire to be employed in this branch of art is manufactured. The metal, which is usually silver, but can also be gold or any other metal, is melted in a crucible and poured into a mold to take the form of a rod. This rod is then drawn through a wire-drawer's steel plate with a perforation narrowing towards one end. This process is very difficult and time-consuming. The plate has to be very firmly fixed. The rod is inserted into the wide end and drawn out through the narrower one, thus becoming much longer and finer in the process. In order to facilitate its passage through the aperture, the metal rod is heated until it is red hot and then immersed in wax. Special pincers are used to draw the wire through the plate Round his waist the wire-drawer wears a thick sash of buffalo hide with metal rings. When the strength of his arm proves insufficient or when the wire is too long, he attaches the end of the wire to the metal rings on the leather sash round his waist and completes the work by walking away from the plate and turning round at the same time. The laborious work continues until a silver rod of 0.5 cm in diameter is drawn out into a fine wire of 1 mm in diameter.

After the rod has been drawn out into a fine wire, the craftsman sketches the work to be done on a piece of paper. If the work is to be in the form of a flat sheet (e.g. a tray) a flat piece of paper will suffice. If, however, it is to be hemispherical in form, as in the case of a cup holder, the sketch is drawn in the form of an open projection which will produce a hemisphere, and the two ends of the paper are then brought together so that the result can be clearly seen and the necessary corrections made.

Telkari work consists of two processes—the first being the framework or skeleton, the second the insertion into this skeleton of the motifs employed.

The work begins with the preparation of the skeleton. The thickness of the wire in the skele-

ton is twice the thickness of the wire used in the motifs. After the skeleton has been prepared, the interstices are filled one by one with very great care and patience. All the work is carried out on a flat walnut board.

In preparing this walnut board the upper surface is burnt to extract the oil. It is then placed under very heavy presses and left for two or three days until it is ready for use. One may feel inclined to ask, "Why not use iron plates?" During the welding process, this plate, which measures 15 x 20 x 4 cm, is held in the hand and brought very close to the flame, so that a metal plate would become very hot, which accounts for the use of walnut. This, however, has sometimes been replaced in recent times by asbestos, which is both noninflammable and a poor conductor of heat.

Next comes the work of welding the individually prepared parts of the main skeleton. And here I should like to correct a misapprehension. Some books on this subject write that the wires are joined by using solder. This is utterly erroneous. Once solder has been used the object in question is fit only for the scrapheap. Solder eats into and erodes the silver. I have seen a number objects which have been repaired in this way by craftsmen ignorant of the old techniques. As a result the work is ruined beyond repair. Once solder has been used, welding is out of the question.

It is very difficult to weld wire only one millimeter thick, because the heat will immediately melt the wires. This process thus demands great care and patience. Silver of a lower carat is reduced to powder by being filed down in a piece of chamois leather. The reason for this is that these small particles will melt more quickly than the wire and will combine among themselves.

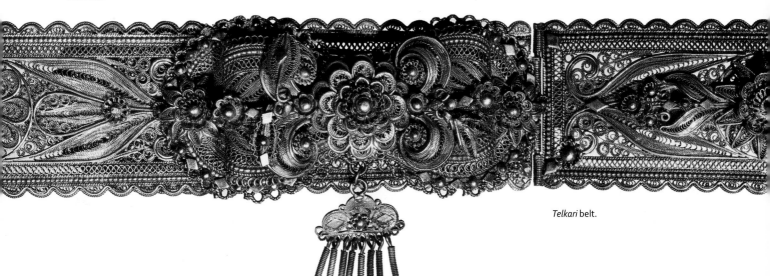

Telkari belt.

35

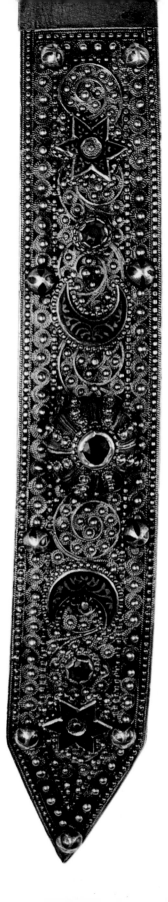

Telkari belt buckle.

The ground silver is placed in a receptacle to which borax powder is added. This mixture of silver and borax is then added to the parts of the work to be welded, each part having first been immersed in water and the whole laid out on a sheet of asbestos. Here the temperature of the flame is of great importance, so an implement is used in the form of an inverted cone made of glass or metal, with a cotton wick hanging down from the pipe section and filled with sesame oil, olive oil, or, if higher temperatures are to be used, kerosene. A blow-pipe with a curved end is used to direct the flame. The walnut board on which the work is placed is held in the hand and brought dose to the flame, while at the same time air is blown out of the blow-pipe. This current of air spreads the flame over the work and thus facilitates the welding process. After the skeleton has been completed the decorative motifs are placed in position and the welding process begun. The work on the motifs is extremely time consuming, and demands great patience and precision.

After this, there are two alternative ways of proceeding:

1. For flat objects: After the work on the skeleton has been completed, the whole is finished off by the addition of sequins or other decorative accessories.

2. For rounded vessels: In the case of hollow vessels, outer molds are prepared of metal or hard wood according to the type of work in hand. The metal molds are made of steel or an alloy of bronze and zinc. The wooden ones are made of hard woods such as beach, coconut or box. Wooden molds are usually used for finer work as it is essential that the work should not be damaged in any way while being given the required shape. In the Southern parts of Turkey the female molds are known as *haşteks* and the male molds as *hafşeks*.

After the process described above has been completed, the flat surface is placed over the female mold and the male mold beaten down on to it by means of a small hammer. After this, light hammering has continued for quite a considerable time, the various parts of the work are welded together. Various decorative accessories can be added if desired.

This process, which is known in the profession as "splitting hairs," was still being practiced thirty or forty years ago. Craftsmen employing this method of welding were continually blowing into the blow-pipe, thus breathing in a great deal of smoke, with the result that many of them contracted diseases such as tuberculosis.

May the dead rest in peace, and may those that still survive lead a long and healthy life!

As for the objects manufactured in the *telkari* technique, these display an infinite variety, ranging from cigarette-holders, tobacco boxes and cup holders, to various kinds of trays and belts, head ornaments and mirrors. The art is thought to have originated in Mesopotamia or Ancient Egypt, whence it spread by one route to the Far East, and by another to Anatolia and thence to Europe.

The most important center in Turkey is the town of Midyat in the province of Mardin. Midyat ware is of very great delicacy and value. Other centers are Sivas, Edirne, Elazığ, Diyarbakır, Trabzon, Bursa and Beypazarı. Until quite recently the art was carried on in Istanbul by craftsmen from these areas. This art aroused great interest in the European dominions of the Ottoman Empire, and became particularly popular in Greece and Spain.

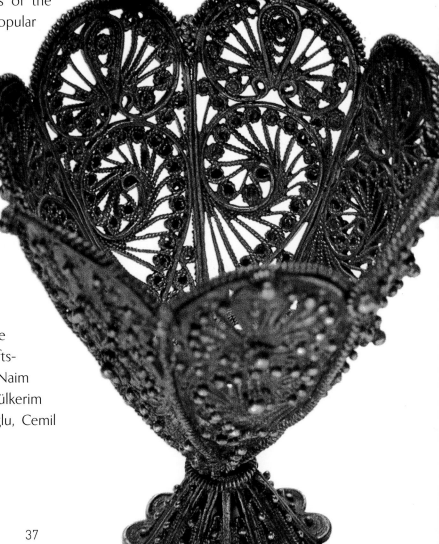

We know the names of only a very few of the craftsmen engaged in this work. One of the reasons for this is the difficulty of inscribing a signature or date on *telkari* work. On pieces having a flat surface, however, the craftsman could quite easily sign his name with a steel stylus.

İbrahim Asil (b. 1529), an old *telkari* craftsman who works in the Çuhacı Han at the end of the Covered Market and who has been of great help in supplying me with technical information, has provided the following list of the most famous *telkari* craftsmen of the last fifty years: İskender Altuniş, Naim Kardeş, Yakup Tecimer, Cercis Güzeliş, Abdülkerim Güzeliş, İlyas Güzeliş, Abdülkerim Nasifoğlu, Cemil Özası, Abid Özası and Musa Araz.

Tombak

In old sources the term *tombak* is defined as follows:

"A mixture of gold and copper." Sheikh Süleyman, *Lügat-i Çağataî ve Türk-i Osmani*, 1880, p. 173.

"Originally derives from Indian and is known by the same name in Europe. Copper or bronze either mixed with gold or gold-plated." Şemseddin Sami, *Kamus-i Türkî*, 1900, p. 910.

"A type of copper or bronze ware plated with a mixture of mercury and gold (applied to the copper by hand)." Nurettin Rüştü Bingül, *Eski Eserler Ansiklopedisi*, 1943, p. 100.

"A yellow alloy containing 80% copper and 20% zinc is known as *tombak*." *Meydan Larousse*, 1973, vol. 12, p. 203.

The various definitions given above remind me of the word yemen which in certain parts of Turkey is used for a shoe, while in other parts it refers to an embroidered muslin scarf wound round the head.

An Indian word deferring to an oriental craft, *tombak* is used in different countries with different connotations.

After this short introduction, I should like to turn to the historical development of *tombak* and its use by the Ottomans.

The history of man's use of personal ornaments as well as his employment of various materials to embellish the objects he has manufactured is as old as the history of man itself. Objects made of cheap, long-lasting materials are given an attractive appearance by being plated with gold. Ornaments and objects used for various purposes which have been gold-plated in this way are very commonly to be found in the Far East, Ancient Greece and Rome, Byzantium, the Seljuk Empire and, above all, among the Ottomans.

As it would be much too expensive to use gold for the manu-

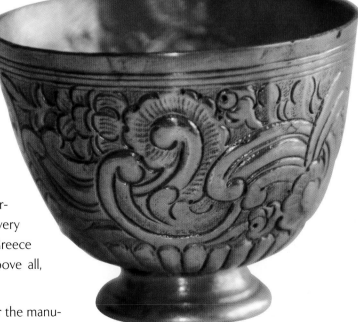

facture of utensils in everyday use, such as hamam bowls, coffee-pots, rose-water flasks, coffee cup holders, *nargile*s (water-pipes), ewers, trays and salvers, these were usually made of copper and then gold-plated.

In my opinion the invention of this technique is a real credit to the human race. On the one hand, it appeals to the eyes and the emotions, while on the other it prevents oxidation. It is thus a technique of primary importance.

Tombak may be defined as the art of applying a mixture of mercury and 24 carat gold to the surface of copper objects which have been prepared with great care and patience by means of a variety of techniques. The art has not, however, been practiced lately since thirty years. When I first met the late Hilmi Asar Bey in the Covered Market a few years ago he told me that he had learned the art from a master from Trabzon but that he had not practiced it for many years and that he knew of no one that continued to practice it. The following description of the process used in *tombak* is based on what Hilmi Bey told me a couple of years ago, old notes kept by friends and the objects themselves.

But before going on to the *tombak* process itself I should like to touch on one more point. The definition given in Meydan Larousse, which was quoted above, makes no mention of gold. But when I asked the craftsmen in the Covered Market why they were melting down *tombak* ware they told me it was in order to obtain gold. (The objects being melted down were generally very old, worn pieces.)

The surface of the object to which *tombak* is to be applied is first rendered absolutely smooth. This is done in order to give the gold a more brilliant shine.

Any dirt, oil or sweat stains are then removed so that the gold can adhere firmly to the surface. Next comes the preparation of the mercury and gold mixture. According to a description of the process given by the bookbinder Mehmet Effendi, Mithat Sertoğlu and İbrahim Asil, a mixture consisting of eights parts mercury and one part very finely ground 24 carat gold is placed in a porcelain bowl and the mixture stirred for about two hours with a piece of wood. In order to ensure that the gold particles have completely dissolved in the mercury the mixture is passed through a fine muslin gauze. The mixture thus sifted should be applied by means of a brush or a piece of cloth wrapped round the finger to the already prepared surface of the object. The work is then held over burning charcoal (not embers) in a brazier so that the mercury will evaporate and the gold left adhering to the surface of the metal. The process is thus completed.

Tombak minaret finial.

40

This final process, in which the mixture of mercury and gold is held over flaming charcoal in a brazier, must be carried out in a well-ventilated room with open windows, as the fumes from the mercury are very injurious to health. As a matter of fact, many of the craftsmen who used to be engaged in this type of work found that, in spite of all the precautions taken, their teeth tended to decay and fall out. Savak Bey, one of the masters of niello work in the Covered Market, told me that he had once tried *tombak* work, but the death of his two canaries while he was carrying out this process led him to abandon it completely.

The decline and impoverishment of the Ottoman State, together with the economic, social and cultural decline to be witnessed in every field, also affected the practice of the art of *tombak*. Not only did it become practically impossible in such circumstances to create new examples of this type of ware, but the difficulty during the war years of obtaining metal from the mines, combined with the pressing need for copper, led to objects that already existed being melted down and used in the manufacture of essential articles.

Although a large quantity of *tombak* ware used to be manufactured and used, for the various reasons mentioned above, there has been a very great decline in the number of such objects now in existence. We hope and trust that museums and connoisseurs in possession of such ware will take the greatest care in its preservation.

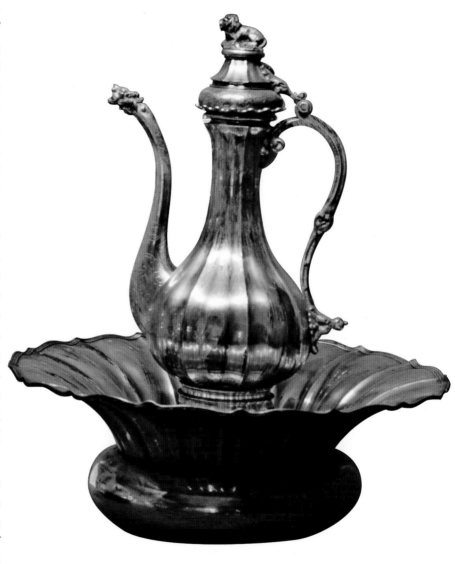

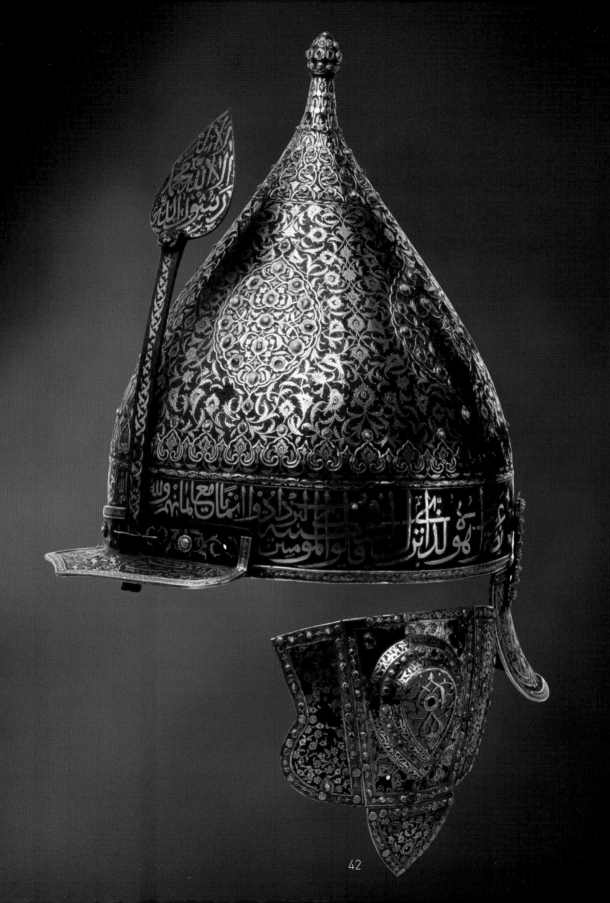

Turkish Style Incrustation

Mıhlama, (ornamental studding or incrustation), resembles other types of silverwork technique insofar as it is not normally used independently, being much more frequently combined with other techniques to achieve a totally individual appearance.

Although incrustation is rarely used in modern silverwork, its application to gold objects in conjunction with precious stones forms a quite independent branch of art, differing very markedly from the type of incrustation applied to silver. In Ottoman times, on the other hand, the same techniques were employed for incrustation in both silver and gold.

Incrustation is used in conjunction with various other techniques such as repousse, niello, filigree and painted decoration, but the socket in which the stone is set is, in some techniques, prepared beforehand, in others afterwards.

For example, if incrustation is to be applied to certain parts of an object decorated in repousse, the repousse is first completed leaving the parts to be used for the incrustation blank. The silver socket is then cut out in accordance with the size and shape of the precious stone to be inserted. The socket is usually cut before being welded to the ground leaving zigzags and teeth in the upper part, and is subsequently welded in accordance with the shape of the base of the stone (round, polygonal, elliptical or asteroid).

The stone is then inserted in the socket and the teeth placed in position over the stone, care being taken not to damage it in any way. In the case of sockets without teeth, the stone is lodged in the socket by using plaster and a steel punch.

This incrustation with precious stones lends a very attractive

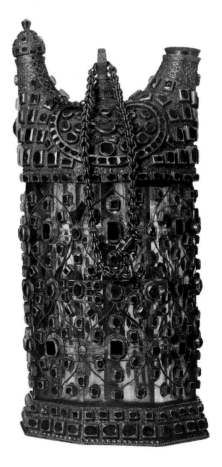

◀ Helmet with Turkish style incrustation and golden ornaments.

A box with jeweled incrustation.

appearance to the object in question. In this type of incrustation coral, agate, turquoise and various types of glass are commonly used.

Let us now turn to incrustation applied to works displaying different techniques and examine how this technique is applied to niello.

The grooves are first of all opened up, but before actually proceeding with the niello, preparations are made for the incrustation, the niello process being left until later so that no harm to the work is caused by the welding process. The sockets prepared for the stone are then welded to the base; the stones are firmly inserted in the sockets and secured by means of teeth or plaster. After this, the usual niello process is carried out.

As for incrustation applied to filigree, the sockets are here welded or riveted in the required places to the already finished silver filigree. Once this process is completed as described above, the precious stones or glass beads are inserted into the sockets and the object is then complete.

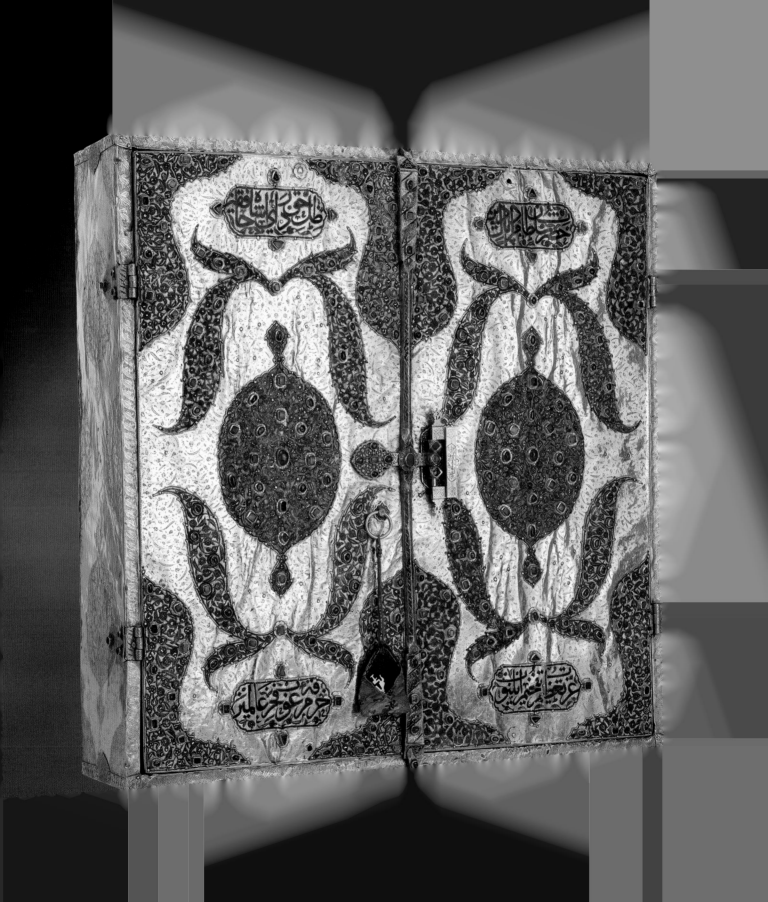

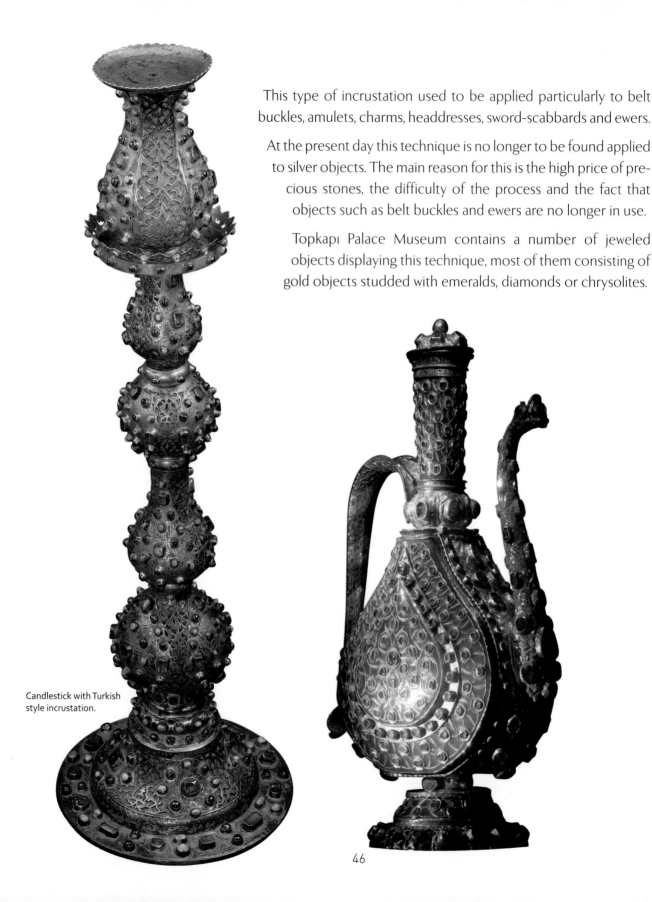

This type of incrustation used to be applied particularly to belt buckles, amulets, charms, headdresses, sword-scabbards and ewers.

At the present day this technique is no longer to be found applied to silver objects. The main reason for this is the high price of precious stones, the difficulty of the process and the fact that objects such as belt buckles and ewers are no longer in use.

Topkapı Palace Museum contains a number of jeweled objects displaying this technique, most of them consisting of gold objects studded with emeralds, diamonds or chrysolites.

Candlestick with Turkish style incrustation.

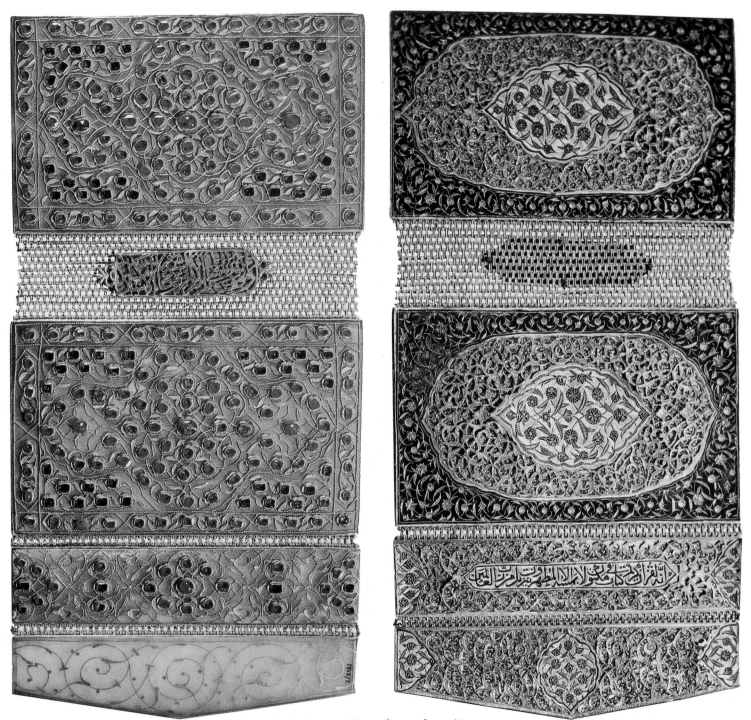

Two Qur'an cases with magnificent craftsmanship.

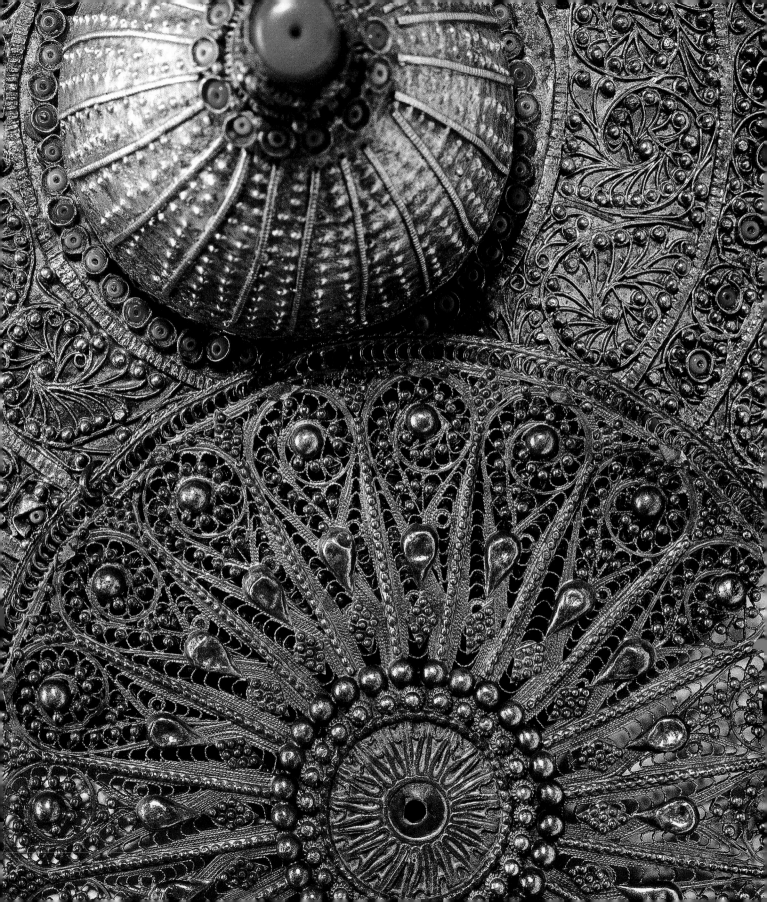

Güherse
(Decorative Beading)

The term *güherse*—sometimes spelt *güverse*—is a word of Persian origin meaning "jewel-like," and refers to decoration consisted of tiny metal beads welded onto articles made of silver and gold. In Turkey the resemblance of these tiny globules to opium seeds led to *güherse* being known as *haşhaş* (opium) work. *Güherse* is a very ancient ornamental technique for metalwork, probably discovered because of the natural tendency for the noble metals to form drops when cooling from the fluid state.

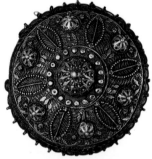

Belt buckle with *güherse* beading.

Mesopotamia, a region which was cradle to civilization in many different respects, is also where *güherse* work was first discovered. From here it spread to other parts of the world, the technique's popularity waxing and waning over the centuries. It was in the hands of Turkish jewelers, however, that it was taken to its final stage of refinement. During the Ottoman period, jewelers became so expert that today it is virtually impossible to replicate their work.

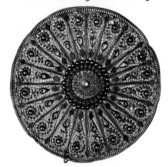

Güherse involves overcoming two major problems; the first to produce equal sized drops, and the second to weld these to the metal surface of the object. The Ottomans mastered this technique to perfection, producing beautiful works of art.

Two practical methods can be used to produce drops of equal size. The first is to wind finely drawn gold or silver wires around a thin nail without leaving any spaces. This forms an even spring, which is then removed from the nail and cut down the center to produce tiny rings. These are placed spaced apart on an asbestos sheet and heated with a blowtorch. As they melt, the rings form drops, which fail into a bowl of water where they cool into equal sized balls. Until thirty or forty years ago this process was carried out on a log of walnut from which the oil had been scorched out.

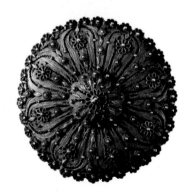

Alternatively the drawn wire can be measured into equal lengths and then melted to form drops in a similar way. However both these methods are only practicable for small quantities. To produce beads by the hundred different methods entirely was required. Oak charcoal was pounded to powder tiny pieces of silver of equal

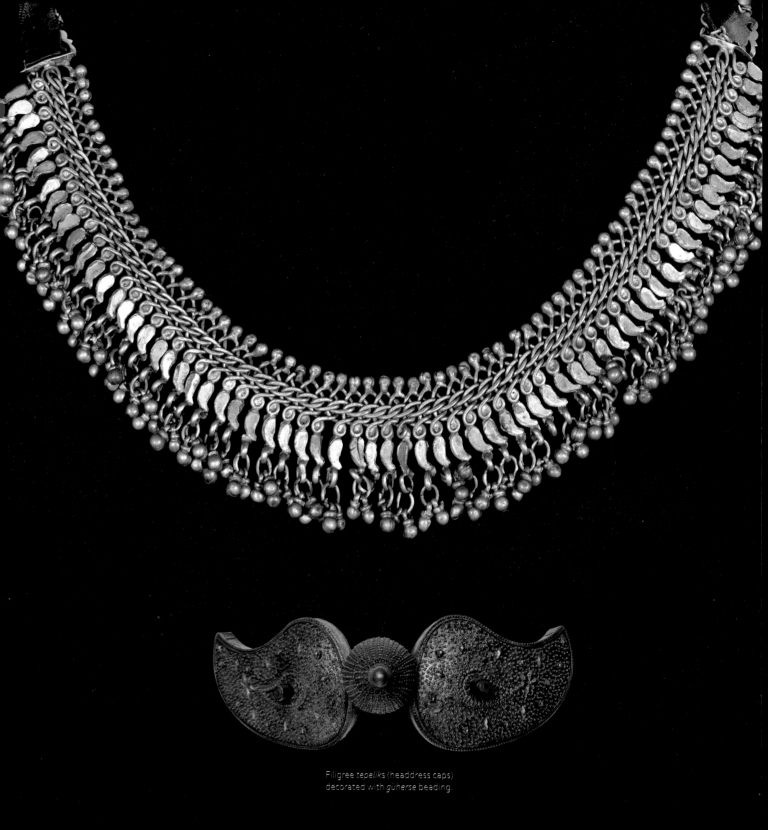

Filigree *tepeliks* (headdress caps)
decorated with *güherse* beading.

Another *tepelik* with *güherse* beading.

size mixed into it. This mixture of silver and charcoal dust was poured into a pan made of cast iron or thick sheet metal, which was placed on a fire of oak charcoal. As the charcoal dust heated to the same temperature as the charcoal fire beneath, the pieces of silver melted into drops, but were prevented by fusing together by the charcoal dust. Although simple in principle, success in practice depended, like so many of the traditional arts, on the skill and experience of the craftsman.

The pan was then removed from the fire and the contents poured into a sieve to remove the charcoal dust. The beads were then poured into sulphuric acid to brighten them.

Every metal and alloy has a different melting point, which is why when two pieces of metal are to be attached, they must be of the same standard. For example, silver beads of 900 parts per thousand must be used on a buckle of the same standard.

Having obtained the silver beads, it was time to weld them to the surf ace. Unfortunately, there are no clear contemporary accounts of the welding techniques used by craftsmen in past centuries.

The technique used today is to gouge out tiny depressions with a sharp ended instrument at the points where the beads are to be welded. This serves both to prevent the beads rolling away and to hold the borax paste which is applied with a brush. A flame is then passed over the work and the balls are thus fused to the surface.

Güherse ornamentation is as delightful as it is difficult, and articles of many kinds were decorated in this way. Buckles, coffee cup holders, *tepelik* (decorative metal caps worn over headdresses), harnesses and scabbards are among the items to be seen in museums and private collections.

(I express my heartfelt thanks to Muharrem Özuslu and Burhan Öztop, who are both from Gaziantep, and are the friends of my father, and to İbrahim Asil from Mardin, all of whom are craftsmen in the Covered Market.)

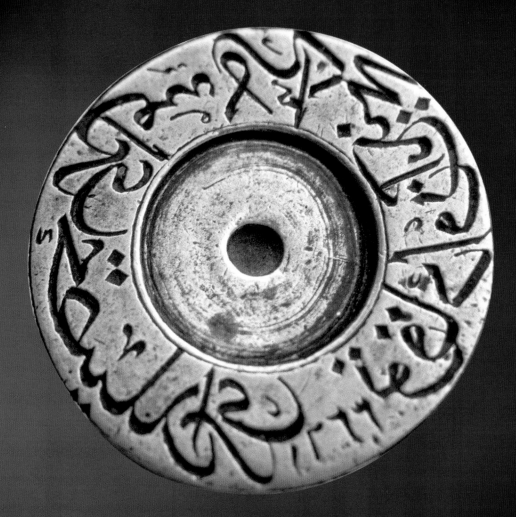

The identity engraved on metal

İlahi eyle abdin hayra alet
Bihakkin mühr-i ali-i nübüvvet

(O God, make your servant an instrument of the good
In engraving the seal of the Messengership.)

The Seal in the Art of Engraving

This is the inscription on the seal of Assayid Muhammad Tahir Effendi.

Let us join with him in praying that God will make mankind an instrument of the good before passing on to our topic.

A seal might be described as an attractive little object made from one or several metals (gold, silver, brass, etc.) or precious stones (emerald, amethyst, agate, crystal, etc.), which bears a name, symbol, motif, sacred verse or epigram engraved into the material in such a way that it can be stamped on to a title deed, letter or some other form of document and which can be carried by its owner on a ring, pendant or watch-chain to serve as a signet.

Agate seal.

Seals are known to have been used from very early times. The figure known as the "Seal of Solomon" was used by the Hittites and Egyptians as well as the Jews, and achieved very great renown.

Seals were known and used in the West as well as in the East, though in ancient Rome the use of seals was confined to very important persons. As locks and keys were quite unknown to the old European tribes anything they wished to keep in safety was closed with wax and stamped with a seal. Western seals usually had pictures or coat-of-arms rather than writing. Julius Caesar's seal, for example, had a picture of Venus.

Prophet Muhammad, peace and blessings be upon him, stamped the letters he sent to the rulers of neighboring states inviting them to accept Islam with a seal bearing the inscription "Muhammadu'r-Rasulullah" (Muhammad is the Messenger of God). This seal was carried as a sacred trust by the caliphs, until the Caliph Uthman dropped it into a well while washing his hands and it was lost forever.

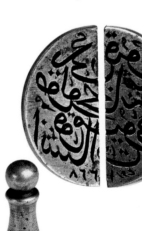

A two-piece seal, a rare piece.

The texts of the letters sent to rulers of neighboring states and stamped with the noble Prophet's seal are as follows: (This letter is kept in Topkapı Palace.)

To Muqawqis, Vicegerent of Egypt

Peace be on him who has taken the right course. Thereafter, I invite you to accept Islam. Therefore, if you

want security, accept Islam. If you accept Islam, God, the Sublime, shall reward you doubly. But if you refuse to do so, responsibility about the Blood of the Arians shall be yours.

O people of the Book! Leaving aside all matters of difference and dispute, agree on a matter which is equally consistent between you and us and it is that we should not worship anyone except God and that we should neither associate anyone with Him, nor make anyone else as our Deity.

If you refuse it, you must know that we, in all circumstances, believe in the Oneness of God.

Seal: Muhammad, the Messenger of God.

The replies sent by the states to which Prophet Muhammad, peace and blessings be upon him, sent letters:

1. The Byzantine Empire (Eastern Roman Empire): After replying in polite fashion to the letter sent by the Messenger of God, the Emperor sent a concubine named Maria, who later became Muslim and married the Messenger of God and bore him a son called Ibrahim.

2. The Egyptian Empire: The Egyptian ruler Muqawqis sent no reply to the letter.

3. The Yamama Empire: No reply to the letter.

4. The Iranian Empire: The Iranian ruler (the Sassanid Emperor Yazdjard III) tore up the letter. Thereupon the Messenger of God said: "O God, he has torn up the letter sent him by Your Messenger. May you tear his empire to shreds in return." Shortly afterwards the Sassanid Empire collapsed as the result of the two wars of 636 and 642.

5. The Abyssinian Empire: Ashama ibn al-Abjar (the Negus), the King of Abyssinia, sent a positive reply to God's Messenger letter and became Muslim.

With the Ottomans, seal-engraving became a very highly developed art combining a number of different artistic skills. The art of calligraphy, for example, contributed outstandingly beautiful compositions employing *thuluth*, *ta'liq* and *diwani* lettering. Only the most highly skilled calligraphers and engravers could so beautifully compress a person's name, surname and additional information into so small a space. Such works resemble tiny posies of flowers rather than inscriptions. The writing is, as it were, embraced by the rumi motifs twining around it, not to mention the exquisite passion flowers, cinquefoils, ivies and roses. The exquisite workmanship applied to the stems of the flowers constitutes yet another specialized art. At the same time, Ottoman

A marvelous seal engraved by the engraver Fehmi Effendi.

A beautiful seal by the engraver Yümni Effendi, 1315 A.H.

Another seal by the engraver Yümni Effendi, 1279 A.H. ▶

54

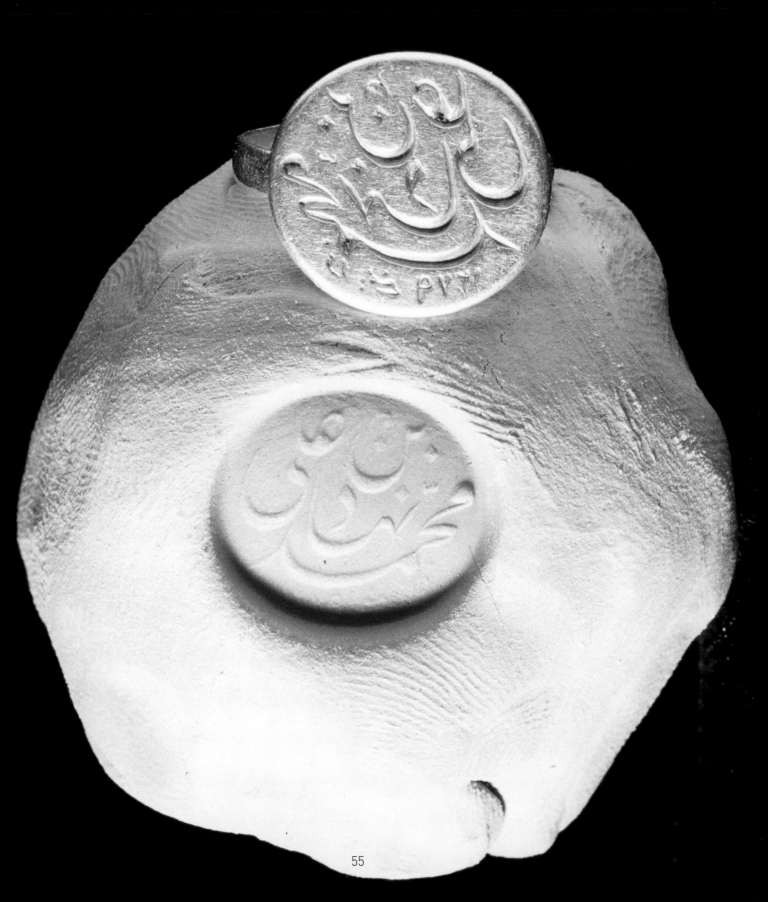

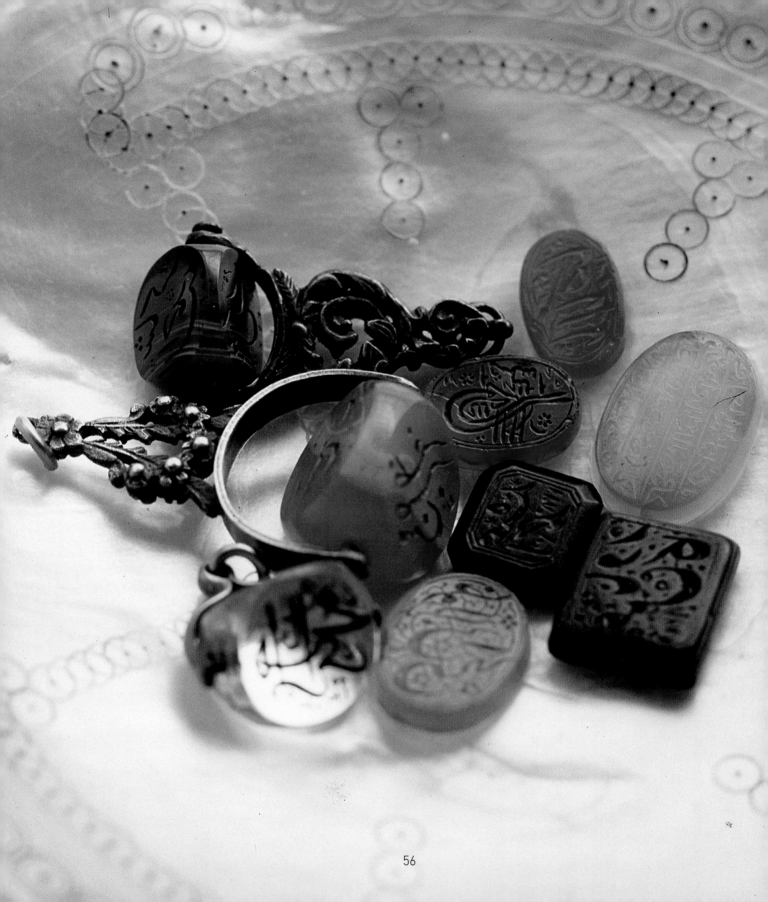

seals reflect the owner's temperament, character, and profession. The member of a religious order is symbolized by the characteristic form of head gear; a captain is represented by an anchor, a physician by the two intertwining snakes known as the "knot of felicity."

In the section of his *Book of Travels* devoted to a description of the seal engravers in Istanbul, Evliya Çelebi divided these craftsmen into three different categories. Concerning the first of these—the "Asnaf Haqqaqan"—he gives the following information: "They have 35 workshops and 105 craftsmen, the leader being the engraver Abdullah Yümni. In the workshops, they engrave agates and turquoises."

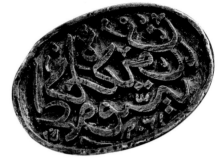

Various seals made out of agate, crystallized quartz, and bloodstone.

The second category consists of the "Asnaf Muhurkunan" about whom he gives the following information: "Their patron saint is the respected Uthman. They have 35 shops with 80 craftsmen. During the reign of Murad Khan, this group included craftsmen of such renown as Mehmet Çelebi, Rıza Çelebi and Ferit Çelebi, who would charge from 100 to 500 kurush for engraving a single seal."

The name Yümni that Evliya Çelebi records as being given to the head of the seal-engravers is part of a tradition that has survived to the present day. The teacher of engraving at the Academy of Fine Arts was called Yümni, and, what is more, his father's name was also Yümni. This seems to us to be a very good example of respect for tradition, respect for profession and respect for the craftsmen.

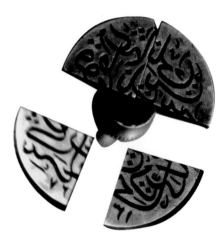

Since the name Yümni has come up let me relate an anecdote concerning him: Baba Yümni was of a very inquiring disposition and an amateur alchemist. He was intent on making gold from clay. While carrying out experiments in this field he also continued with his craft of seal-engraving. A connoisseur of the time who had heard of his skill in seal-engraving came to Yümni and gave him an order for several seals. "Make these seals for me and I'll teach you the chemistry of making gold," he said, and went off. Yümni worked hard at his task and by the appointed date he had produced a series of masterpieces. The man who had ordered the seals arrived with his retinue and examined the seals, admired them, and handed Yümni a purse full of gold coins, and said, "Gold is your profession, why do you try to make gold from clay?" From that day on, Yümni made gold by engraving inscriptions on gold.

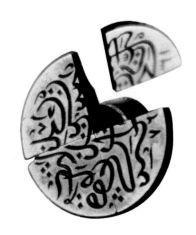

Another multi-piece seal.

◀ The seal of the Ottoman Public Debt Administration.

A great many engravers as renowned as Yümni have appeared in the course of the centuries. We know their names from their signatures placed like a flower on the seals they engraved: Fanni, Mithli, Thami, Ashqi, Zaki, Dana, Bandaryan, Ali, and Azmi.

Besides protecting and encouraging the various branches of the fine arts, the Ottoman sultans also indulged in them themselves. Some sultans were amateur seal-engravers just as others were amateur calligraphers, musicians and workers in mother-of-pearl. Mahmut I, for example, engraved seals which he sold secretly, giving the money he earned as alms to the poor and needy. (I should think there is no need to stress the faith and tact involved here.) At the same time, Evliya Çelebi records the following in his account of the city of Trabzon in his *Book of Travels* (vol. 2, p. 91):

"Trabzon is famous for its craftsmen. No jewelers in the world can compare with the jewelers of Trabzon. Ottoman Sultan Selim I, who had spent his younger years in that city, was trained as a boy in the art of gold-engraving, and engraved a coin in Trabzon in the name of his father Bayezid Khan, which coin your humble servant has actually seen. Since that day the jewelers of Trabzon have been held in great renown."

Proverbs and memorable saying occupy an important place in Turkish seals. One often finds proverbial sayings such as "Man sabara zafara" (Victory goes to the patient) or "Man dakka dukka," (The biter is bit) and there are also quite a few seals that reveal the owner's temperament as well as his profession. The seal of Abdullah Effendi of Amasya is one of these.

İdüp hizmet tarik-i Kadiri'ye bekledi dergah
Olup namı Celal-zade o na'l-bend
Doktor Abdullah bin İbrahim Agah, 1318

(Servant of the Qadiriya order and keeper of the (dervish) lodge
That blacksmith by the name of Jalalzadah
Medical doctor Abdullah, the son of Ibrahim Agah, 1318, A.H.)

Let us end as we began with an example of a seal with verse inscription. This seal was engraved for Imra of Töke, who reigned as king over Central Hungary during the Ottoman ruling:

Muhibbim, mutıim, hazırım emre
Kıral-ı Orta Macarım, ki namım Tökeli İmre.
(Devoted servant, humble, obedient,
I am the King of Central Hungary, my name is Imra of Töke.)

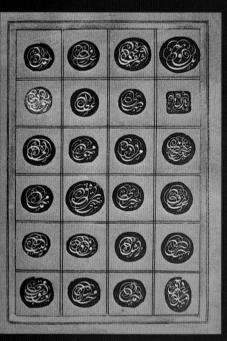

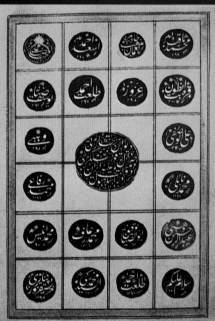

Examples of pages used by the engravers to stamp the seals they made.

Ottoman Cup Holders

Coffee was discovered in Ethiopia but coffee drinking was perfected as an art in Turkey. The new beverage was served in tiny china cups without handles, placed in metal holders known as *zarf*, which both protected the cup and prevented the drinker from burning their fingers. Since it was the holder which was visible this became a work of art decorated with numerous techniques.

Ethiopian pilgrims to Mecca carried coffee with them as a remedy for tiredness on the long and exhausting journey. They in turn had learnt of this drink made by boiling coffee beans from shepherds, who as legend has it noticed that their goats became livelier when they ate the beans. They tried it as a means of keeping awake, and added it to their repertoire of herbal remedies. But coffee was rediscovered by Turkish pilgrims who tried it in Mecca and introduced it to Istanbul, where in time coffee became an integral part of the rituals of etiquette and hospitality. Foreign envoys were served coffee when they paid official visits to Turkish statesmen, and so it spread westwards, eventually to become the most popular beverage in the world.

In the past Turkish coffee cups were made of glass and wood as well as china and porcelain. Those made of fine pipe clay with painted designs were often exquisite, as were those made in Iznik and Kütahya. Not all Turkish coffee cups were made in Turkey. First China and later European porcelain factories such as Meissen in Saxony and Sevres in France made cups for the Turkish market. The cup holders in which they fitted were generally locally made, and reflect the styles of the periods and

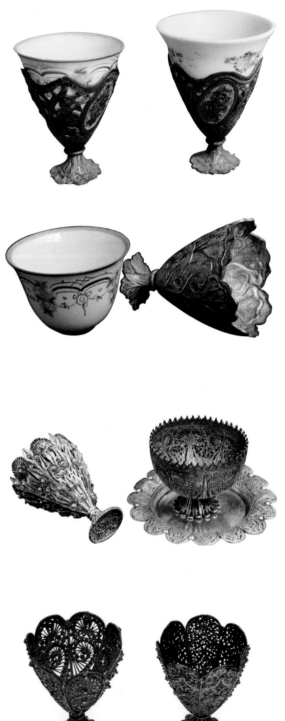

Various cup holders.

61

regions to which they belong. So many varied and fascinating examples of coffee cups, cup holders and the other paraphernalia of coffee drinking and preparation exist that they could fill museums devoted to this subject alone.

Coffee cup holders were often but not invariably made of metals, whether gold, silver, copper or brass. Others were made of hard and scent, woods, such as ebony, coconut or agallochum, and still others of substances like tortoiseshell, ivory or horn.

Metal cup holders were sometimes filigree work, sometimes decorated with chasing, engraving, niello or studded with gems or coral. Chased cup holders were made by first beating out the metal into a sheet 1–15 mm thick and either beating it into the desired shape to fit the cup or forming it into a cylindrical shape and welding the join. Once shaped it was filled with a mixture of tar, asphalt, horasan (a mortar made of pounded brick, dust, and lime) and paraffin, to cushion the blows of the implements while the metal was being decorated. Once the design was completed, the cup holder would be heated up so that the filling softened and could be poured out. It was then possible to further work the design from inside the holder, and so accentuate the motifs. Finally the foot was made and fixed to the holder by a screw.

Silver was the most common metal used for cup holders, followed by copper and brass which were affordable by more people. Copper cup holders were often gilded to prevent tarnishing by a technique involving the application of a mixture of gold and mercury. This type of copper gilt was known as *tombak*.

Engraved decoration in similar designs to those of chasing were produced by using sharp steel styluses to gouge fine lines in the metal. Filigree work was made by first drawing metal wires 1 mm thick, then weaving into the desired shape and finally welding the ends. Alternatively individual motifs were made and then welded together to form a cup holder.

Regrettably very few wooden cup holders have survived. They were fragile but often extremely lovely, as those which remain to us show. Such cup holders were favored because of their fragrance as well as beauty. Some were decorated with motifs cut out of fine silver sheet with a fretsaw, and had silver wire around the rim to prevent them cracking. Before the lathe was in widespread use, these wooden cup holders were made by bow saws or carved.

Tortoiseshell, horn and ivory holders required special skill to make. In the first two cases sheets of tortoiseshell or

Cup holders with latticework.

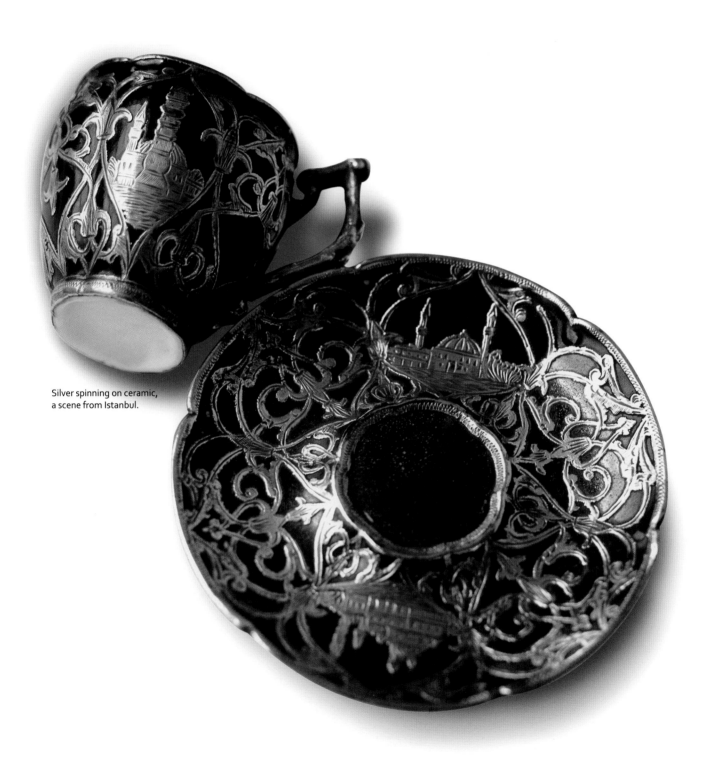

Silver spinning on ceramic,
a scene from Istanbul.

horn were softened in hot water and then clamped between female and male molds of metal or hard wood. Once shaped, they were sometimes decorated with gold or silver inlay. Ivory was carved or sawn into shape by the same methods as used for wood, and then carved decoration applied. Since ivory was so precious great care was taken with the decoration.

Guests were presented with their coffee in these delicate cups and holders, together with water in crystal glasses. In wealthy homes or palace circles the ceremonial of serving coffee in past centuries was lengthy and complex. Coffee was far more than a pleasant substance to drink, but a symbol of hospitality and respect for the guest. So it was no wonder that so much artistry and fine workmanship was poured into these tiny objects.

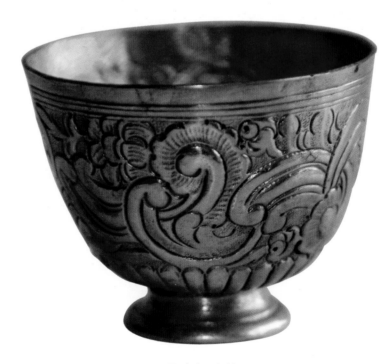

Tombak cup holder.

Offering coffee in the Ottoman Palace. ▶

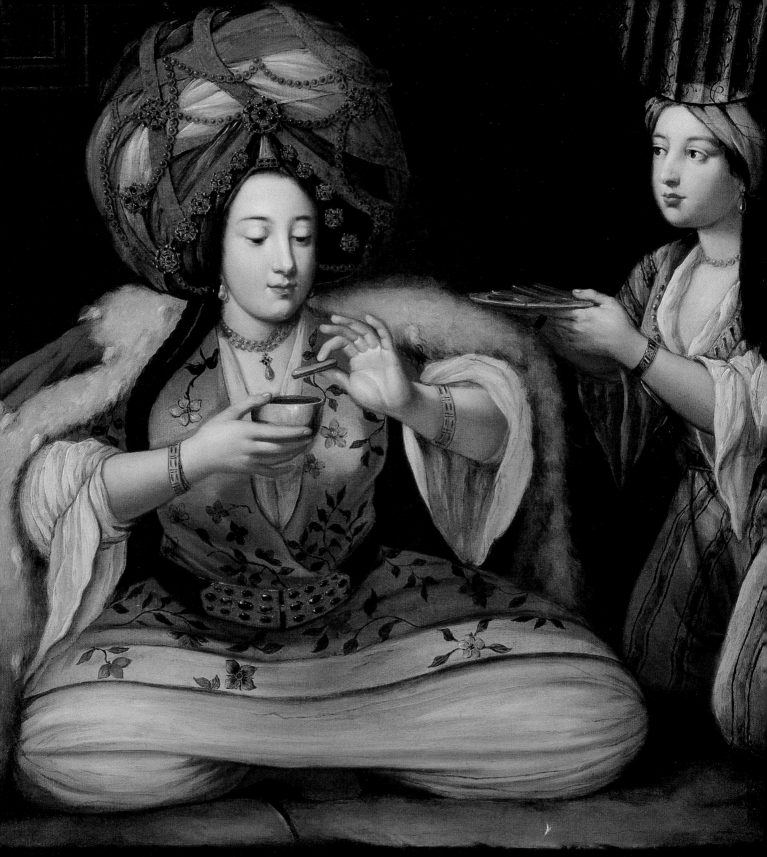

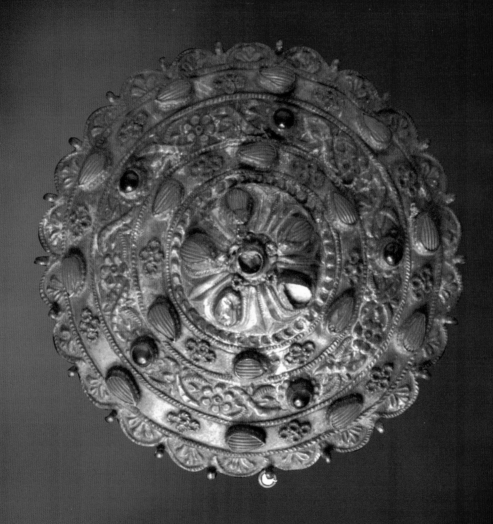

Tepelik
(Headdress Ornament)

Tepelik is an ornament, usually of silver but sometimes also of gold, placed on the top of a woman's fez or directly on the muslin covering her hair. *Tepelik*s wholly or partly covering the fez were usually flat, domed or in the form of a bowl. Various techniques were employed in their ornamentation.

The women of Anatolia wear these *tepelik*s on joyful occasions such as engagements, "henna evenings" (the night before the welding day), and weddings. Young girls, with their plaits hanging down to their waists, take their *tepelik*s out of their trousseau chests and add their own happiness to that of the happy pair.

*Tepelik*s usually display the characteristic features of the region in which they are made and worn. Particular attention is attracted by the *tepelik*s especially made by city craftsmen for wealthy families.

The people of Anatolia, bound as they are to tradition, the soil and their environment, seek happiness in the home and have little interest in foreign parts. This has led them to make the most of what they have, and to develop it by means of new and original techniques. They exploit the material at hand in the finest way possible, producing a variety of objects that are essentially the same but differ in form.

That explains the difference between the *tepelik*s to be found in neighboring towns. For example, Van is famous for its *tepelik*s in niello, while in Bitlis the *tepelik*s are in silver repousse with pointed boxes. A little further on we come across the filigree *tepelik*s of Mardin with gems inserted in the interstices. The combination of gems and filigree produces an effect as colorful as a peacock's tail. *Tepelik*s of gold-plated copper produce a quite dazzling effect in the sunshine.

The *tepelik*s in the Mediterranean and Aegean regions are usually in repousse but differ in motif from the repousse *tepelik*s belonging to other regions.

Besides the *tepelik*s that completely over the fez, there are also domed *tepelik*s with silver coins dangling on chains around the

Bride fez from Maraş.

67

fez. In Central Anatolia, particularly in the Sivas region, the silver coins are fixed directly to the fez, without any chains, and are so arranged to leave no empty spaces between them, leaving the fez entirely covered with silver coins.

There are also what are known as *ferahi*s, consisting of round metal plates placed on the top of the fez. The *ferahi*s worn by women are distinguished from those worn by men in the richness of their decoration.

There are innumerable varieties of *tepelik*, but we should mention the very lovely and individual type of *tepelik* worn by the brides in the Gaziantep and Maraş regions. These fezes are made of silver gilt thread, with the whole of the surface absolutely covered with embroidery. Some of these fezes have spangles hanging from tassels of silver thread.

Nowadays the wearing of a *tepelik* has become a thing of the past. The brides that once wore them stored them away in chests, and their grandchildren later took them out and exchanged them for plastic kitchen ware, while the purchaser would take them off to be sold at the nearest jeweler.

As there is now no market for such things, the old *tepelik*s are melted down for silver. Thus, one of the most important of the old Turkish ornaments has almost entirely disappeared.

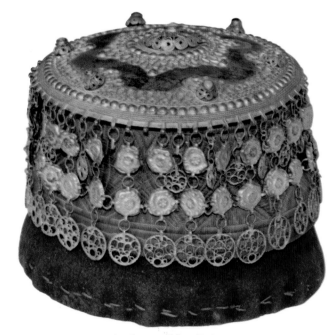

Another *tepelik* from Gaziantep.

68

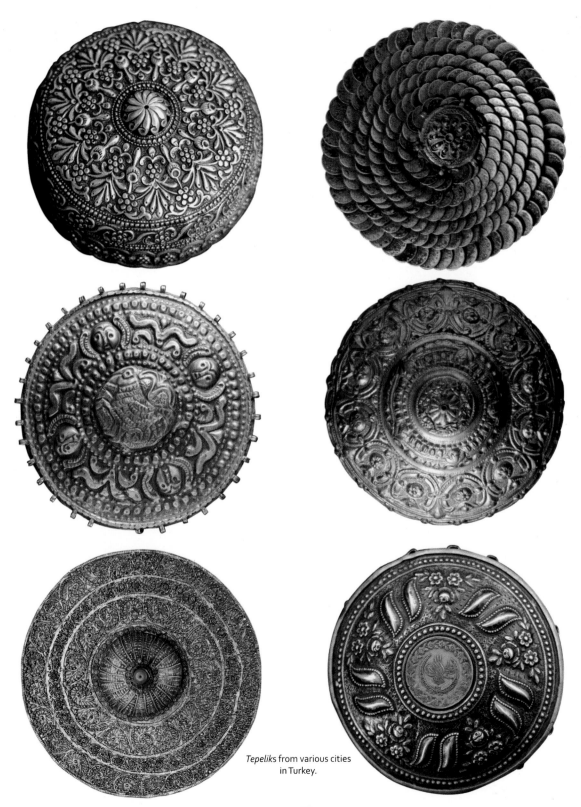

*Tepelik*s from various cities
in Turkey.

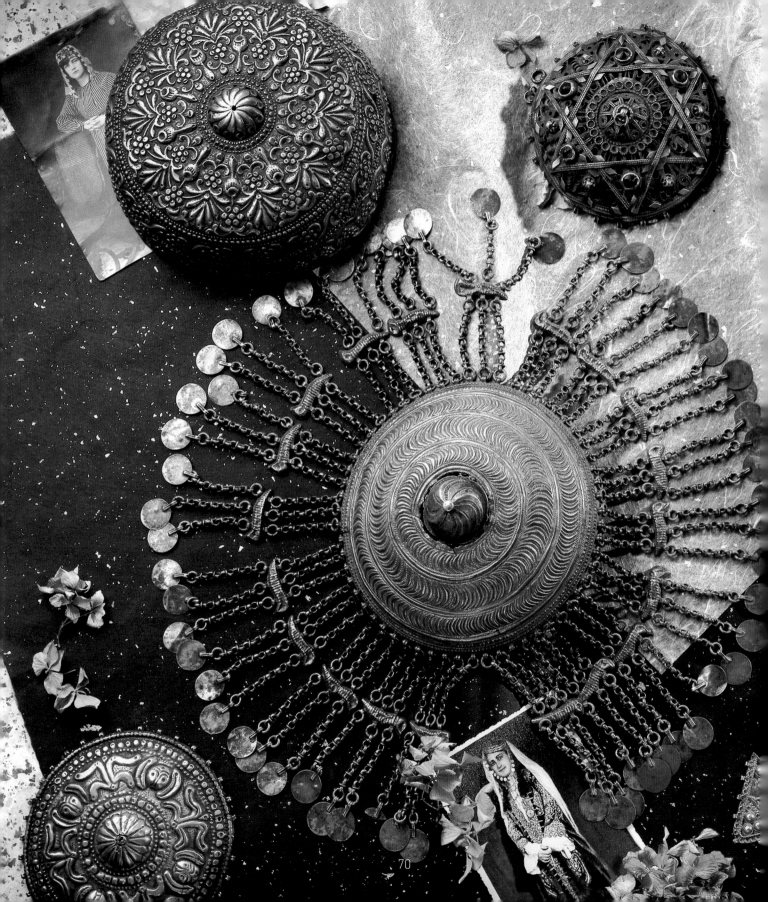

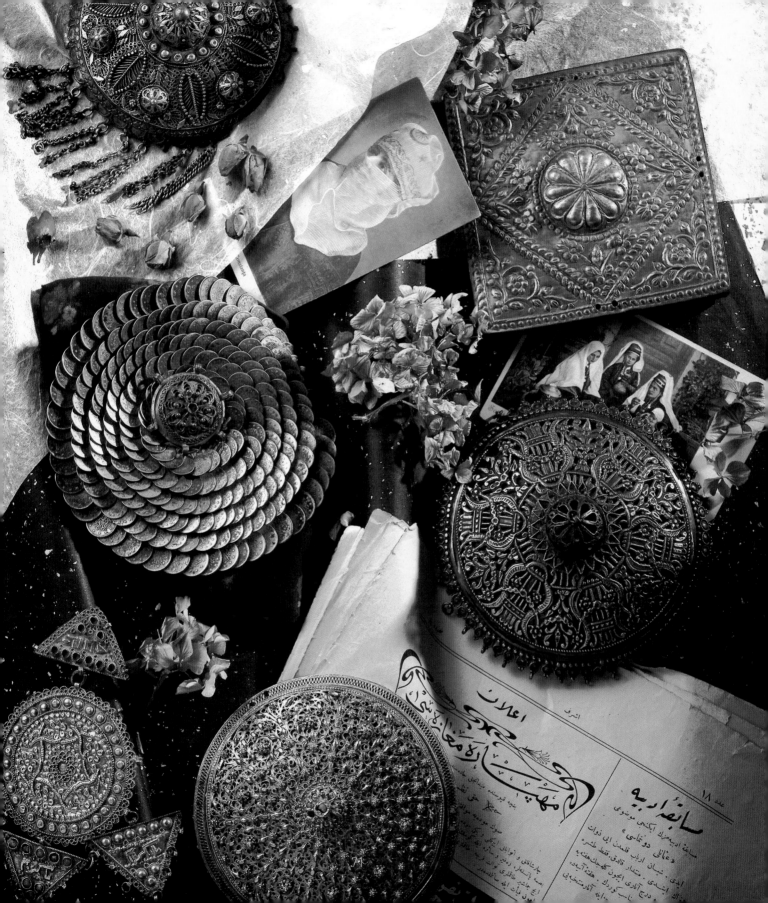

From Talisman to Ornament
Muska and Hamaylis

There used to be a number of small objects of various shapes—triangular, square, rectangular or round, sometimes star-shaped or serrated—worn straight or obliquely round the neck. Such ornaments were commonly found among the Asian tribes, but they were also encountered among the Turks.

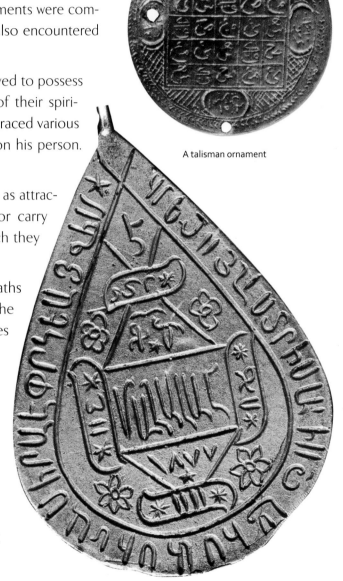

A talisman ornament

People have always appealed to individuals they believed to possess mysterious powers to help them in the realization of their spiritual or material desires. These usually wrote words or traced various forms which the client was advised to carry around on his person. This was the origin of the talisman or charm.

It is a natural instinct to try to make one's appearance as attractive as possible, and people soon began to wear or carry around with them various objects they liked and which they believed would add to their appearance.

At a certain point, therefore, the two separate paths merged into one, and people began to enclose the charms and talismans they relied on in beautiful cases of precious metals and display them on their person.

There would be no point in dwelling here upon the actual nature of talismans and charms. We are interested, not in the actual talisman itself, but in the receptacle in which it was contained.

In other words, we intend to dwell rather upon the value in the context of Turkish art of the metal receptacles made for *muska*s written for a variety of purposes and preserved by their owners with the greatest care.

A silver talisman ornament in pear form with Armenian inscriptions.

73

In certain regions of Anatolia a *muska* was immediately written for every new-born child and given to it to wear. We also find amulets or *muska*s being worn to protect the wearer from illness, and evil spirits. Before the discovery of quinine, malaria was a very wide-spread illness, and many people carried *muska*s specially written to protect them from the disease. In some cases, however, amulets were found to be of little avail. "Your charm," writes the poet, "gave no protection against love. O sheikh, with your claims to magical powers, why don't you squeeze your amulet and drink its juice!"

The Turkish word *muska* is derived from an Arabic word meaning "something written." The *muska*, written by a man of spirituality on a long strip of paper, was popularly supposed to protect the wearer against illness and the evil eye. Later it was folded into the form of an equilateral triangle. In order to prevent any contact with water it was wrapped in a waxed cloth and inserted in a leather bag. It was then hung round the neck or attached to one's clothes by means of a safety pin.

A silver talisman ornament.

Hamayli is also derived from Arabic. Its original form was hamail and meant the cross-shoulder strap for a sword, but it was later used to refer to an ornamental accessory.

Muska cases were generally made of silver and decorated with inlay in a variety of designs. Coral and precious stones were often employed in the inlay, and invested the *muska* case with exceptional beauty.

The *hamayli*s were rectangular, square or round, and in Eastern Anatolia, and particularly in the Van area, were decorated in niello. Most of them were adorned with motifs such as mosques, sprays of flowers or coat-of-arms of the Ottoman State displaying all the delicacy of pen-and-ink drawings.

The *muska*s and *hamayli*s in *telkari* (a kind of filigree work) were of exceptional delicacy. In order to prevent water penetrating the filigree the wires were backed by a metal ground.

The triangular, square and rectangular *muska*s and *hamayli*s gener-

Talisman seal.

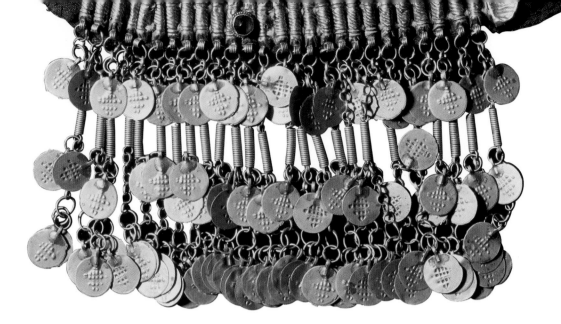

ally had a sliding lid. This lid would be drawn open, the writing inserted and the lid again closed. Sometimes chains were attached to the rings on top of the lid and on the edges of the *hamayli* so that it could be hung around the neck.

Whatever the actual shape of the *muska* or *hamayli*, in the case of those not worn by men, short chains were attached to the bottom of the case to the ends of which silver coins were hung. Sometimes these coins would be replaced by silver spangles made by the craftsman himself. Such ornaments were usually worn on feast days and holidays, and the spangles would produce a tinkling sound with each movement of the body.

In olden times *muskas* became a sort of "trade mark" of the wrestler.

The *muska* and *hamayli* cases that had at first been intended as receptacles for written charms and talismans were later used by young people purely as ornaments containing inscriptions.

In families that were unable to afford having new ones made the young people wear *hamaylis* belonging to their elders.

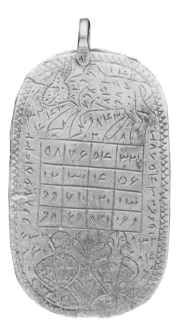

These days, when we have lost so many fine traditions, *muskas* and *hamaylis* are melted down like so much scrap metal for the sake of the silver. The value of these old keep-sakes, which are only now beginning to be regarded as ethnographic material worthy of preservation in our museums, is not yet fully appreciated. The tradesmen and craftsmen in the Covered Market take these very often damaged and worn old *muska* and *hamayli* cases to pieces and reassemble them in quite a different form,

Another silver talisman ornament.

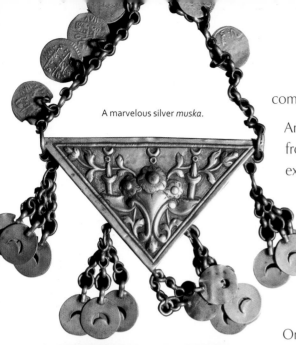

A marvelous silver *muska*.

completely destroying the original concept.

Another depressing aspect of the same problem is the disappearance from Anatolia of the old traditions. It is as if Turkish culture had never existed there, as if the true owners of the land had abandoned it to be settled by people of quite a different culture.

I should like to end this article by quoting a short story from Tuhfa Hattatin, in the hope that it may persuade owners of *muska*s and *hamayli*s, which belong in content to our folk culture and in form to traditional Turkish art, to preserve them as carefully as they can.

On one occasion, greyhound races were being held during Sultan Bayezid II's period of office as governor of Amasya. One of the sipahis (cavalrymen) sought out the father of the great calligrapher Sheikh Hamdullah, bringing him a present of an *okka* (1283 gram) of meat, to ask him to write a *muska* for his greyhound to the effect that it would outstrip the governor's dog and catch the hare. The sipahi was very upset to learn that the Sheikh's father was away from home. "Don't worry," said the Sheikh, "taking the meat from the sipahi's hand, "I too am qualified to write *muska*s. Tie this around your dog's neck." he said, writing something on a piece of paper and giving it to the sipahi. When, in the event, the sipahi's greyhound outstripped the governor's dog and seized the hare there was general amazement and everyone began to wonder what had been written on the *muska*. When it was finally opened they found that the Sheikh had written the following lines:

I took a fancy to his meat and wrote a *muska* for his dog.

Whether the greyhound wins or not.

Ottoman ornaments were popular in Europe.

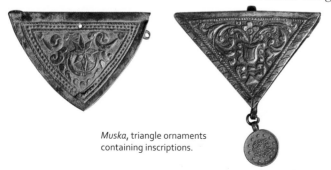

Muska, triangle ornaments containing inscriptions.

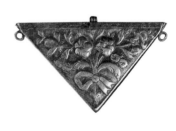

Enameled and transfixed *muska*.

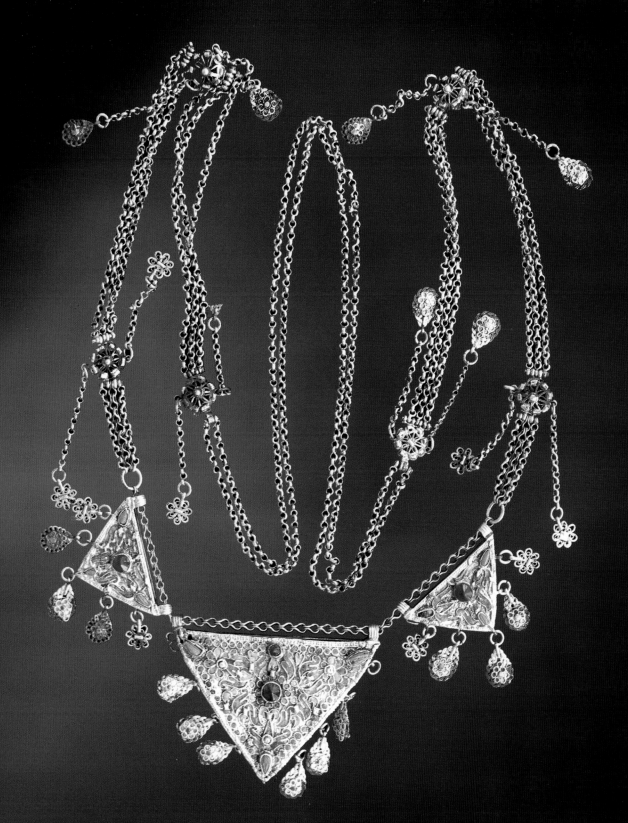

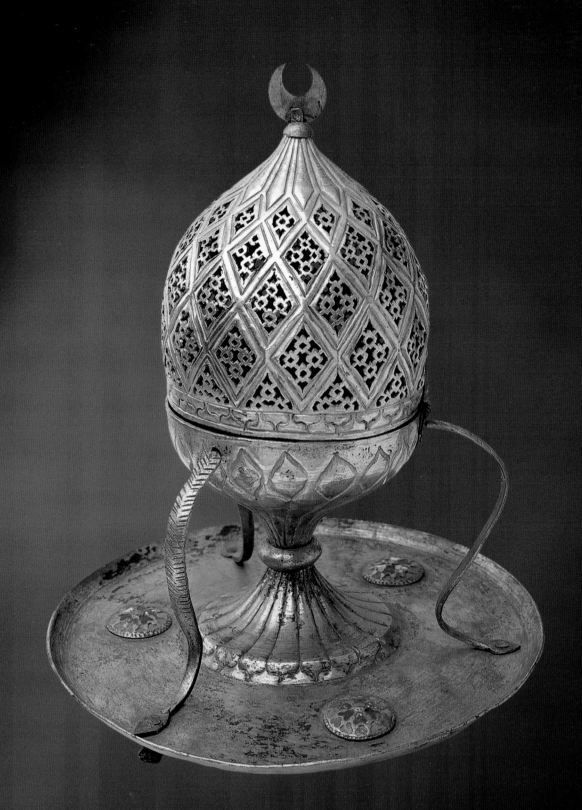

Censers
The Common Heritage of Nations and Religions

"There is only one path of reason" is a saying that for centuries has provided a point of agreement for all men in search of beauty and truth. For example, it is highly significant that societies having no knowledge of each other and stemming from utterly different races and backgrounds should agree on their conception of God. That people were able to adopt a communal way of life is the result of their following the single path of reason.

When people gather together in a closed space, the smells arising from sweat and other bodily functions make it practically impossible to breathe. From the earliest times the wood obtained from trees such as aloe and musk that produce a fragrant perfume when burned have been used to counteract these odors, and this practice led to the invention of vessels in which incenses could be burned.

For the reasons given above, I should regard any attempt on the part of any particular nation to claim the invention of the censer, or to trace the passage of the censer from one nation to another as pure fanaticism. Censers have always been used and are still being used for both religious and secular purposes by African, Asian, European and American tribes as well as by Buddhists, Jews, Christians, and Muslims.

Muslim Turks have had their share in all this, and have produced very beautiful artefacts by giving the common original the shape and form particularly suited to the needs of their own social and religious life.

Censer with embossed silver.

Incense was discovered by some ancient tribes and first used in sorcery or some rituals. Only later was it used in rites of a more sophisticated nature.

Incense has been used in every period of Turkish history. With the spread of Islam and the conversion of the Turks of Asia Minor, the employment of incense became a custom in the Anatolian Seljuk and Ottoman states, particularly in gatherings of a religious nature.

The censer may be regarded as a very small brassier in which incense is burned instead of charcoal, and, like the brassier, it has a dome-shaped cover with holes to allow the passage of air through which the perfume from the incense burning in the lower section is diffused. As far as form is concerned, censers usually reflect the architectural characteristics of the period in which they were made, though they are very often to be found in the form of various fruits, pine cones or poppy seed-cases.

As in many other branches of Turkish decorative art, most censers were made of silver, the techniques most commonly employed being that of wrought metal or openwork. The silver was first of all beaten flat and then molded into the form of a sort of architectural model by using hammers and anvils. It would then be sent to a master craftsman for embossing, for which process the censer would be filled with pitch and the design beaten on to the surface by means of

Steel chisels. Other censers would have painted decoration instead of embossing. The censer would usually be placed on a tripod with very elegant curved legs, which itself would be placed on a tray of matching form and technique. The censer would be suspended on three chains forty or fifty centimeters long from a ring or some more complicated type of holder. The chains were used in order to swing the censer freely in large gatherings.

Gülabdan (rose water dispenser), the "brother" of censer.

A *tombak* censer. ▶

80

Censers in the form of candle-sticks were known as *micmer*. These also were made of various metals. Incense sticks consisting of amber, or fragrant woods ground into powder and molded into the form of candles were stuck into these micmer and burned.

Incense was used as a means of practicing a sort of magic in which desires could be fulfilled or the evil eye banished.

Although it was used to freshen the air in closed rooms incense was obviously of very little efficacy in the open air. This gave rise to the expression "to burn incense in Ok Meydanı (the Archery Field)" referring to unnecessary, futile activity. For those who actually remember the old Ok Meydanı the phrase is particularly meaningful.

In the hope that all our efforts will produce the good, the beautiful, and the useful.

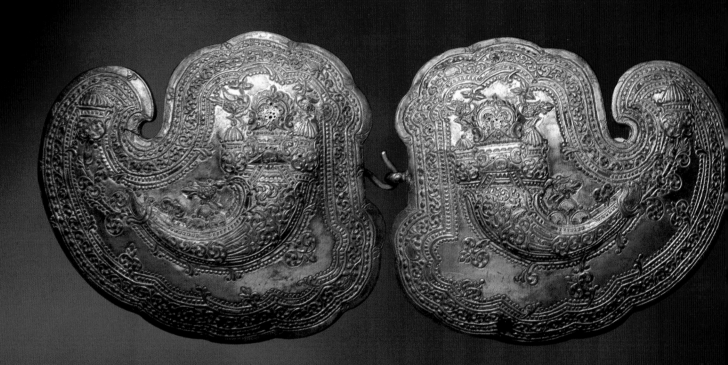

The mirror of splendor

Ottoman Belts and Buckles
The Mirror of Splendor

The belt is something we have inherited from the steppes culture of our ancestors of the second century B.C. For the Turks it was even then an indispensable object of apparel rather than a mere ornamental accessory. The various objects unearthed in the excavations carried out in the ancient Turkish tombs of Central Asia include a number of belts and buckles made from gold and other metals using a number of different techniques. These belts were to end up, after the rise and fall of so many Turkish states, and after having been molded and kneaded for so many years in the hands of the Anatolian Turks, as the belts and buckles we shall be discussing below.

The belts that are now to be found in songs, poems and old pictures were once an integral part of our adornment and apparel. There were a number of different belts worn on particular occasions by everyone, regardless of their sex or social status. These belts were so popular that even dervishes wore belts encrusted with agate, bloodstone, jade, etc., even choosing them as emblems of their order.

A belt may be defined as an article of apparel ranging from two to five inches in width which is wound once around the waist and terminates in a buckle. In some belts the hole, together

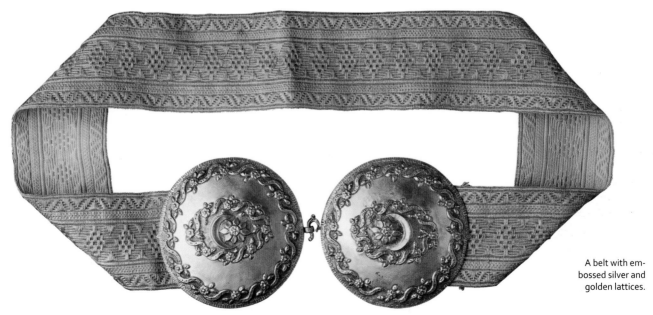

A belt with embossed silver and golden lattices.

83

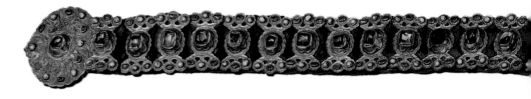

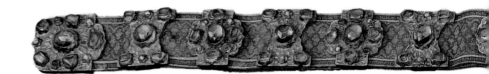

with the buckle, may be regarded as a single work of art, but in most cases it is the buckle in which the artistic importance of the whole is concentrated.

Belts were not, like sashes, articles of everyday wear, being rather reserved for use with the special costume worn on feast days and holidays. It was a tradition, for example, to bind the belt around the waist of the bride. The father of the bride or, if the father was dead, the nearest male relative, would bind as costly a belt as he could afford over the purple velvet and silver embroidery of the bridal dress. The bride would leap over a sword and her father would then caress her back and pray that she would be blessed with good and worthy offspring.

A Turkish belt reflects the character of both the nation as a whole and of the particular region to which it belongs. For example, in the Black Sea region it was the custom at wedding feasts and entertainments to wear belts of gold and silver, while in Eastern Anatolia they would wear sevadlı silver belts and in Central Anatolia and Thrace belts of filigree. Istanbul belts, in particular, were encrusted with precious stones and had gold or silver buckles, usually set with semi-precious stones such as jade or coral.

Of the jeweled belts made for the palace those specially made for the Sultan were used for various purposes or on special occasions. For example, in the ceremony of the girding of the sword all the members of the armed forces would attach their swords to chains hanging from the belts around their waist. In the Ottoman

A miniature painting with a depiction of a belt by Levnî.

84

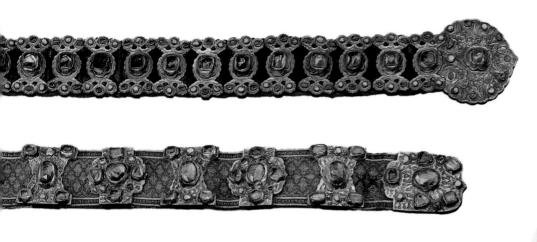

palace, this sword-girding ceremony was the equivalent of a royal coronation in the west.

One day during the week following the ceremony of the taking of the oath of allegiance the new Sultan would leave the palace after the Morning Prayer and go to Eyüp with his imperial boat.

Here he would visit the tomb of Eyüp Sultan where he would perform the ceremony of girding on the sword. (The sword would be hung from the belt by means of two chains, one short and the other long.) The Sultan would then return to the palace on horseback, visiting the tombs of his ancestors on the way. This ceremony of the girding on of the sword was first performed by Murad II in Bursa in 1421. Mehmet II had his sword girded on by this teacher Aq Shams al-Din at Eyüp Sultan after the conquest of Istanbul.

Everywhere in Anatolia one can find plain or inlaid belts with buckles decorated in inlay. We may make the following rough classification of the different types of belts:

1. Specimens in which both the belt and the buckle are of metal. These were generally of silver, though rich families would have belts made of gold.

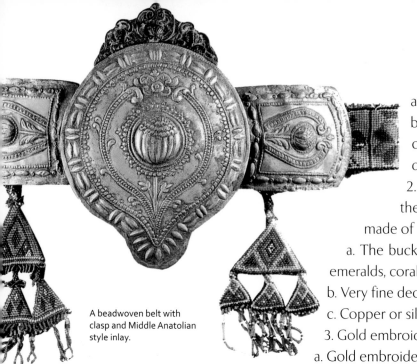

A beadwoven belt with clasp and Middle Anatolian style inlay.

a. Doing sevat on silver

b. Filigree

c. Basket-weave

d. Painted decoration

2. Belts made of cloth with buckles of metal. In these only the buckle was decorated. The belt was made of some sort of costly fabric.

a. The buckle was encrusted with precious stones such as emeralds, coral, agate and jade.

b. Very fine decoration in relief.

c. Copper or silver plating (gold plating using mercury)

3. Gold embroidery on costly fabrics

a. Gold embroidery on costly, self-colored fabrics

b. Metal belts made by various techniques on a belt made of cloth

4. Belts with a single stone surrounded by metal. These were generally made of agate, and consisted of plain belts worn by members of the religious orders. They were particularly popular with the Bektashi dervishes.

It occurred to me while writing these lines that my admiration for these, to me, very beautiful objects may well be due, to some extent at least, to national prejudice. It would be interesting to consider what members of other nations have thought and written on this subject.

I rushed off to the library. In one corner of my desk were the various belts I had previously selected, (belts I should certainly buy if I could afford them) together with the photographs you can see in front of you now.

A belt clasp with Istanbul style inlay.

I should like to quote extracts from the works of two westerners, one a woman and the other a man, who had the opportunity of becoming acquainted with various different aspects of Turkish life. The first is Lady Mary Wortley Montague (1689–1762), who came to Istanbul as the wife of the British ambassador Lord Manchester and acquired a great deal of knowledge concerning our social and family life. The letters she wrote from Istanbul were published in England in 1763 and have been translated into a number

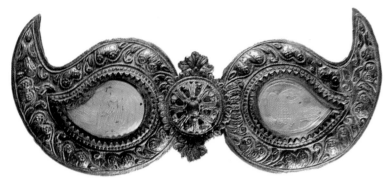

An embossed silver belt clasp in almond shape and mother-of-pearl center

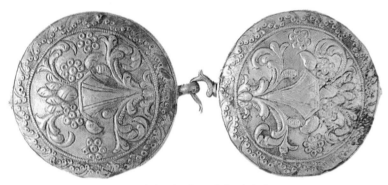

A *tombak* and embossed silver belt clasp

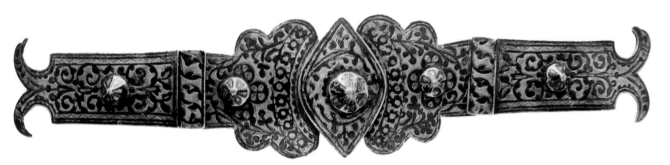

A belt clasp in *savat* work

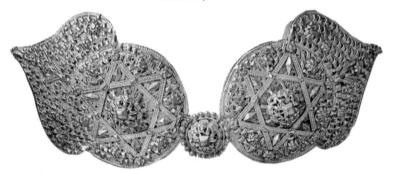

A belt clasp with *güherse* work and the seal of Prophet Solomon.

of different languages, including Turkish. Here I should like to quote a few paragraphs from a letter written to her sister describing female costume.

"... First of all I have a wide shalwar, with slippers of white leather embroidered in silver. Over my shalwar I wear a chemise of white silk entirely covered with embroidery. The sleeves of the chemise are very wide and fastened up to the elbow with diamond buttons.

The shape and color of the breasts are clearly visible through the chemise. Over this is worn a kind of jacket cut according to the body and edged with thick gold and silver embroidery. The buttons are of diamonds or pearls and the sleeves hang down behind. The dress fits me exactly and descended to my feet.

Over this is worn a belt about four inches wide. The belts worn by rich ladies are encrusted with diamonds and other precious stones, but those who do not wish to involve themselves in so much expense wear belts of embroidered satin. The belts are fastened in front with a diamond buckle."

The second authority from whom I would like to quote is M. de Ferriol, the French ambassador. M. de Ferriol, however, feeling that words were incapable of giving an adequate idea of the beauties he wished to describe, particularly of the things he saw on his travels, brought with him the Dutch painter van Mour. The ambassador and van Mour stayed for twelve years in Turkey and thus had the opportunity of familiarizing themselves with many different aspects of Turkish life and of drawing a great many sketches of the costumes worn by a number of people whose acquaintance they had made, particularly Sultan Ahmet III himself.

An album containing van Mour's sketches, together with a written commentary, was published in Paris in 1712 and aroused so much interest both in court circles and amongst the general public that it very quickly went through three editions.

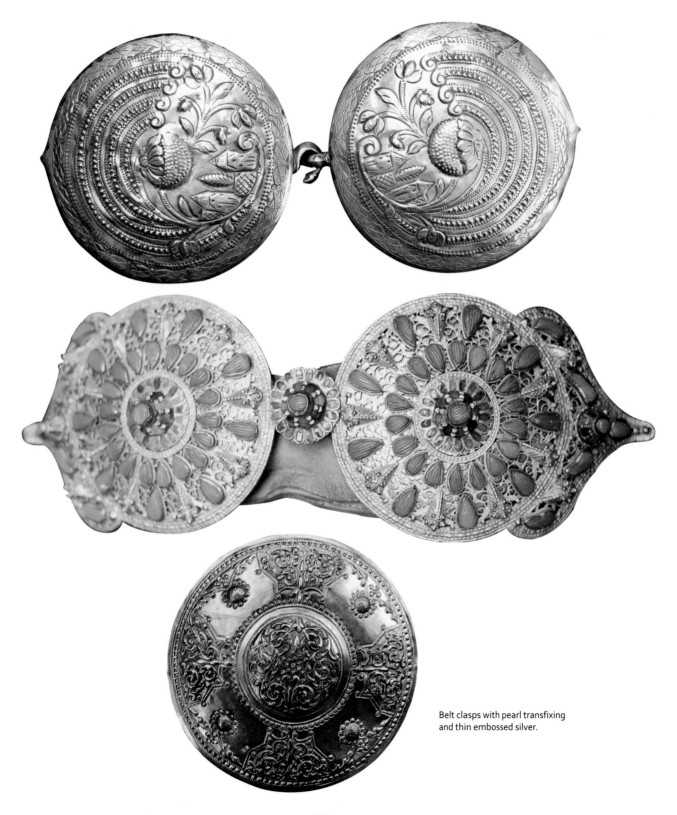

Belt clasps with pearl transfixing
and thin embossed silver.

90

Ornamented Back of Mirrors

The origin of the mirror may be said to lie in man's desire to see himself with his own eyes. The first mirror was probably the still waters of a pool, but this function was soon to be performed by polished metal, a type of mirror we find employed by the Seljuks. The Sumerians were the first to use the glass mirror, which later made its way to Europe and to Venice in particular.

In this article I should like to consider the frame and back of the mirror, which were far more valuable than the mirror itself.

Among the Turks the mirror was something one set with its face to the wall once one had finished actually using it. The large pier-glasses with their Baroque frames only entered our mansions in the Tanzimat period in the nineteenth century. Prior to that mirrors were only used when people were arranging their hair or going out, and young people were taught that it was a sin to stand gazing into the mirror. When I was young I pondered quite a bit over this without being able to really understand it and even sometimes making fun of it. Now that I see young people spending hours in front of the mirror I realize that it was not so foolish after all.

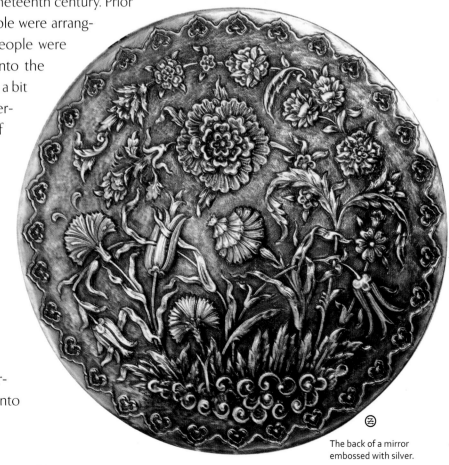

Beauty of outer appearance is very important for people with not a thought in their heads. But we should never forget, and we should teach younger people, that our bodies will some day betray us, and that then only knowledge and skill will be of any avail.

The Turks have generally regarded the mirror as a sort of admonition. In looking into

The back of a mirror embossed with silver.

the mirror they became aware of a deeper dimension. Its moral and religious significance led them to employ it as a symbol in literature, art and mysticism.

Our ancestors created works of art in wood, ivory, iron, silver, mother-of-pearl and gold in various techniques such as carving, inlay, relief and embossing, ail displaying a great variety of animal and plant motifs.

One example of this is the masterpiece of ivory carving on the mirror in the Topkapı Palace Museum said to have belonged to Suleiman the Magnificent, and, if you think a work of such delicacy would be more suitable for a woman's hand, you can console yourself with the thought it is quite possible that it was made for Hürrem Sultan. It is an example of classical Ottoman art at its zenith, with the *thuluth* inscription running round the edge, the decorative band of hatayi motifs, and finally the border with its decoration of hatayis and rumis separating the decorative band from the rosette in the center. It was very difficult to create designs in the classical Turkish style. The moment the pattern or balance was upset everything was ruined. Here it was impossible to solve some problem by merely inserting a flower or a stem, as was done in Baroque art for example. One had to seek some other solution. In this the mirror played a very important role.

A hand mirror embossed with silver.

Until the eighteenth century the mirror remained within very modest dimensions and displayed a very restrained use of decoration. Then, quite suddenly, it broke out of the bonds imposed by its function and became a decorative, ornamental symbol of luxury, opulence and pleasure. This applies, of course, mainly to the court and its dependencies. The ordinary people continued in the old traditional path.

I should like to quote a few lines from Haluk Şehsuvaroğlu on this subject:

"From the eighteenth century onwards, the mirror began to play a

very important role in interior decoration.

A number of pier-glasses and console mirrors were included in the gifts presented to the Ottoman Sultans by foreign ambassadors. A large mirror with silver frame was among the gifts presented to Mustafa III by the Austrian ambassador in 1762, and around the same time the Prussian ambassador gave the Sultan a large mirror with a double silver frame. The gifts brought by the Polish ambassador in 1777 included a Parisian type pier-glass and several Polish type mirrors with amber frames.

Later it became the custom for foreign statesmen to present mirrors to the Ottoman Sultans, and mirrors were to be found applied to a great variety of objects in the palaces, such as cupboards and chests of drawers, while at the same time we hear of mirrored rooms, mirrored pavilions, mirrored carriages and even mirrored shops. The Aynalıkavak Pavilion on the Golden Horn was decorated with mirrors imported from Venice."

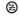

A "cushion mirror" embossed with silver.

Most Turkish mirrors were made of mother-of-pearl or silver. In the case of mother-of-pearl mirrors, a hollow was first of all carved out in front to hold the actual mirror, painted decoration was generally applied to the reverse of the wood after the mother-of-pearl had been put in place, and finally mother-of-pearl was placed in the frame surrounding the mirror on the front. The reverse face on mirrors of this type usually displayed a Seljuk eagle, Ottoman coat-of-arms or flowers. Some of these were provided with a chain for hanging on the wall, others had a handle. These mirrors with either chains or handles were known as "cushion mir-

rors," the reason for this being that in old Turkish houses mirrors were laid on the straw-filled cushions on the divans and settees. Most of the silver mirrors were embossed, but I have also encountered specimens in gilt copper and filigree. In wealthy families the same techniques were applied to gold, and these were often encrusted with precious stones.

Very few of the old silver mirrors have survived to our own day, most of them having been melted down to make coins or for some other purpose, and the mirrors that have managed to survive mostly date from very recent centuries. Mother-of-pearl mirrors were usually stored away in damp attics as being old-fashioned and out of date, with the result that the wood has rotted away and the mother-of-pearl disintegrated.

As a plea for the conservation of the mirrors we still possess I should like to quote a line from the beautiful panel in *thuluth* script written in 1292 A.H. (1876 C.E.) by Ali Effendi, one of the most famous Turkish calligraphers:

The back of a mirror embossed with silver, with flower illustrations.

İtme mir'âtı şikest seni yüz sûrete kor.
(Do not break the mirror, or it will break your face into hundred fragments.)

A picture by the painter Osman Hamdi Bey. ▶

94

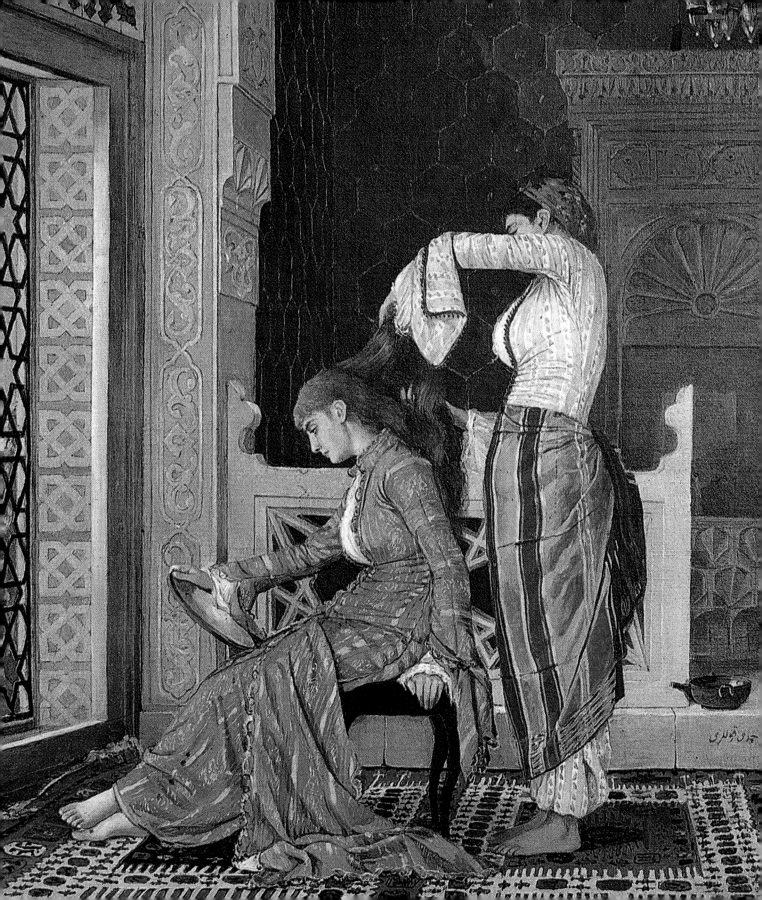

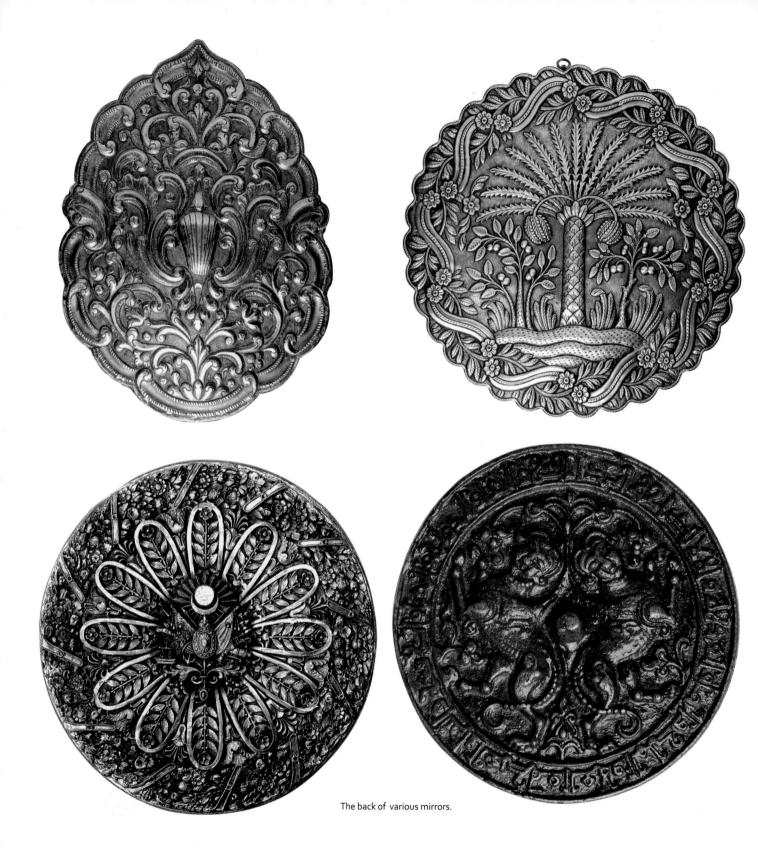

The back of various mirrors.

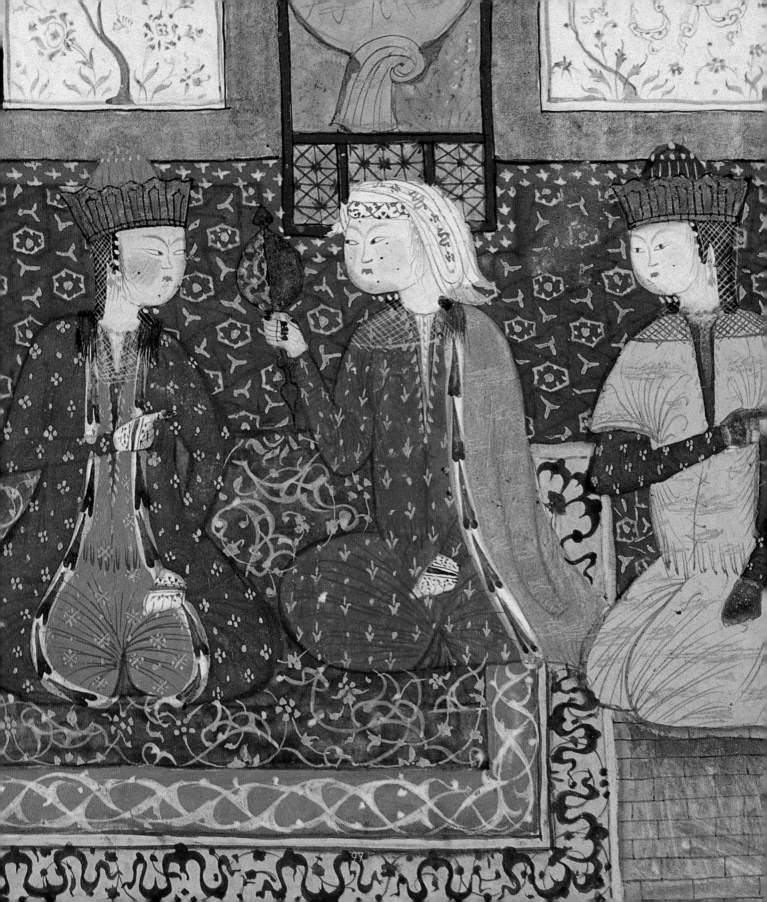

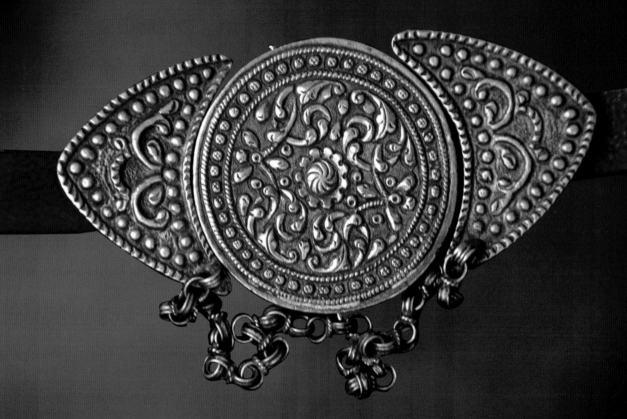

The pride of heroes

Bazubend
The Pride of the Brave

Bazubend is a kind of amulet consisting of a small receptacle, usually of silver, containing a paper inscribed with prayers against sickness or misfortune, supplications or even jokes, wrapped up and preserved in waxed paper or a piece of cloth and bound to the bazu (or pazu), the muscle of the upper arm between the shoulder and the elbow that functions as a flexor—the biceps, in other words.

Early examples of these amulets are to be found in Hittite reliefs, Egyptian frescoes and in the groups of statues in Buddhist temples. In those days they appeared to be used as ornaments, or as symbols of strength and nobility.

The examples of these amulets seen in Turkish and Islamic miniature paintings indicate the place occupied by the old cultures in the new religion.

The continuation of this tradition among the Turks is demonstrated in Seljuk and Ottoman works of art. One example of a young man wearing one of these amulets is to be found on an octagonal tile from the Kubad-abad Palace now preserved in the Karatay Museum of Tiles and Ceramics in Konya.

But these amulets cannot always be said to have continued to perform the same function. With the Ottoman examples, which were normally made of metal, we find beauty and use combined with their former significance.

Until quite recent times, *bazubend*s constituted a sort of trade mark of the wrestlers. They believed that by binding it to their arm the strength of that arm would be increased. In the old days they used to describe a strong, powerful man as a "pazulu adam"—man with pazu. As the old poet says:

The wrestler that has both cunning and a valuable *bazubend*

will have no equal anywhere in the world.

This clearly shows how intimately wrestler and *bazubend* were associated.

The *bazubend* did not, however, always contain a piece of writing. A traveler setting out on a journey would put gold coins or precious stones in his *bazubend* to see him through to his destination.

In these cases conspicuously valuable *bazubend*s would be replaced by more modest specimens of purely sentimental value. These *bazubend*s also performed the function of identity discs.

As *bazubend*s were never removed from the arm, save when absolutely necessary, they were never lost through theft or negligence. They were never removed even in the bath, and the bath attendants would always treat customers wearing a *bazubend* with particular respect, the *bazubend*s being regarded as a Symbol of pride, nobility and superior taste.

*Bazubend*s were the subject of many of the popular anecdotes related by the old maddahs. Let me give an abridged version of a story of this type I heard from my cousin, the late Ali Bayram, a highly accomplished story teller, "The Sultan sets out to tour the country in disguise. One day he sees a village girl, falls in love with her, and later marries her. When the time comes for him to return to the palace he gives his lovely bride a *bazubend* encrusted with diamonds. 'If you become pregnant,' he says to her, "and give birth to a girl, you can sell this and use the money for her dowry. If you have a boy, give him this *bazubend* and, when he grows up, let him wear it on his arm and seek me throughout the land.' One day, the village girl gives birth to a strong, healthy boy. In due time, she tells the handsome prince the whole story, gives him the *bazubend* and instructs him to seek out his father throughout the land. After many trials, hardships and adventures, he comes to his father's kingdom and finds his father the Sultan. The Sultan then calls his beautiful wife to his side and they live happily ever after."

That's how the story ends.

Stories such as these clearly indicate the importance of the *bazubend* and its widespread use in social life. Unfortunately, they are now rarely to be encountered. A friend of mine in the Kapalıçarşı, in the course of conversation, happened to remark, "Master, I've melted down in my own time, enough *bazubend*s to fill the whole of that shop to capacity." I leave the reader to make his own judgment.

*Bazubend*s usually consisted of three parts. There was the round or square section into which the writing was inserted. On each side of this there were sections with pointed ends made to fit the circle or the square. These sections were kept separate so as to lie easily and comfortably on the arm, but were joined by means of a hinge. Under these three sections were soldered metal attachments through which the strap was passed. This strap generally ended in a buckle, though sometimes silver links were passed over it.

*Bazubend*s varied widely in accordance with the taste and financial status of the owner. Most of

them were decorated with silver inlay, painted motifs or niello, while others were encrusted with coral, agates, emeralds, turquoises or colored glass.

The *bazubend*s displayed a great variety of techniques combined with a wealth of motifs, the most commonly used being stars and crescents, the hexagonal stars known as the "Seal of Solomon," various flowers, maşallahs and other written formulas.

Although each of these *bazubend*s displayed great differences, they all formed an inherent part of the spiritual world of the artists responsible for their creation. Nevertheless, *bazubend*s were one of the first of the old traditions to be sacrificed as the result of changes in our way of life, and the first to be melted down in the crucibles. Those that escaped this fate continued their existence as cream-or powder-cases.

It is our earnest hope that one day these *bazubend*s, now a thing of the past, will once again become fashionable.

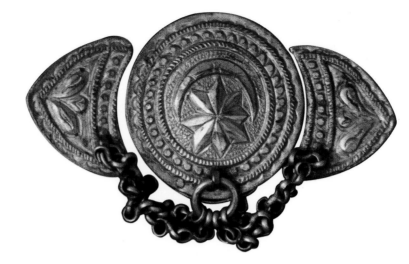

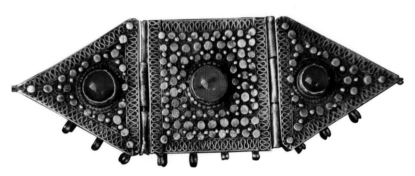

A *bazubend* with *güherse* and agate transfixing.

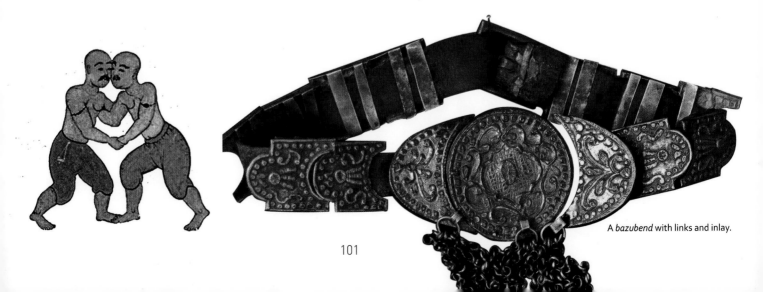

A *bazubend* with links and inlay.

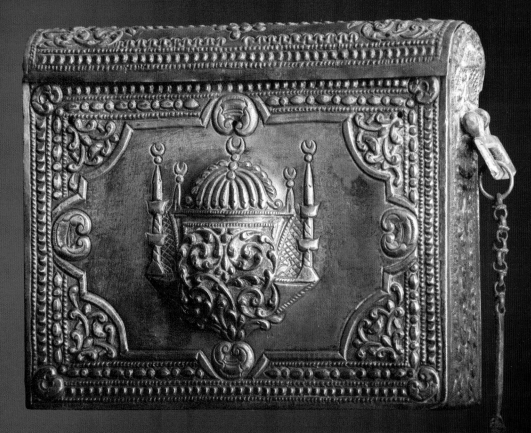

O Qur'an! You deserve every respect!

Silver Mushaf Cases

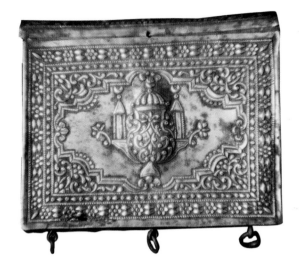

Men have always endeavored to provide receptacles in keeping with the material or spiritual value of the objects it is their function to preserve and keep. *Mushaf*, as the Muslim's most treasured spiritual possession, has always been preserved with the utmost care and devotion.

Mushaf is simply another word for the Qur'an, The term was originally used to refer to a number of pages gathered together, and only later assumed its modern connotation. At first, the Qur'anic verses and chapters were not in a single volume. During the caliphate of the respected Abu Bakr, all the pages were bound together, and the resulting volume became known as a *mushaf*.

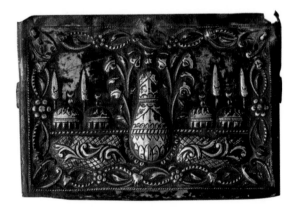

This Holy Book was copied in the finest calligraphy of which the human mind and skill is capable, and illuminated, bound, and preserved in a container that would be worthy of its contents.

The size and shape of the cases varied greatly in accordance with the variations in size and shape of the *mushaf* itself. In this article I shall be concentrating on silver *mushaf* cases of relatively smaller dimensions.

Although all the various techniques that are normally applied to silver can be found in these *mushaf* cases, the most common form of decoration is a type of repousse producing the impression of relief work. These cases were always especially commissioned, and never bought ready-made in the market-place, and perhaps we should stress at this point that the same holds true of the *mushaf*s. Only *mushaf*s forming part of a deceased person's estate or put up for sale by a needy owner were ever sold in the market.

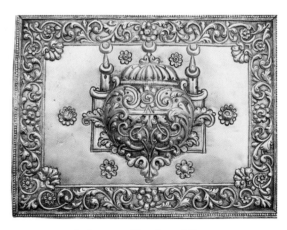

Men of taste would have their *mushaf*s copied by the finest calligraphers and illuminated by the most celebrated artist. Attention was then turned to the provision of a beautiful binding and preparation

Qur'an cases with embossed silver.

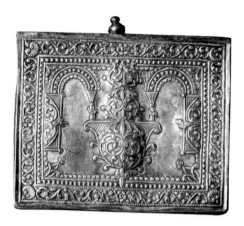

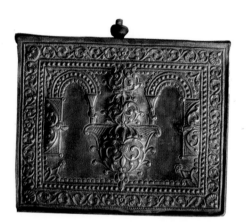

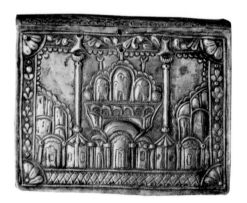

Qur'an cases with embossed silver.

of a silver case in which it was to be preserved. I am referring, of course, to a time long before lithography began to be used in the production of copies of the Qur'an. But even for many years after the introduction of the new processes, the wealthy continued to prefer the old methods.

Preparations were made in accordance with the special techniques to be employed in the production of the case. In this article I shall concentrate on silver repousse, the most common technique employed, and touch only briefly on the other methods.

Once the dimensions of the case had been decided, some parts were made as a whole, others separately. A case would consist of a decorated front face, a back either left plain or adorned with the Seal of Solomon motif, the bottom and two side sections, all joined together to form a bow, topped by a sliding or hinged lid. The most important feature of the case was the harmony of the whole produced by the individual parts.

Although different masters would follow a slightly different approach the general method employed was as follows.

The silver was cut out in accordance with the dimensions of the case to form the front and rear faces, the bottom and the two sides. These pieces of silver were then immersed in pitch and the already prepared designs transferred in reverse onto the silver by means of a steel pen. The design was then applied in repousse using steel punches. When this process had been completed the work was heated and the pitch removed. Once the silver had attained a red heat it was cleaned by immersion in sulphuric acid.

As soon as the silver assumed a whitish color it was removed from the sulphuric acid, rinsed in water and dried. The design would then appear in relief on the front face. The pieces were then once more immersed in pitch and the ground surrounding the designs to stand out more clearly, after which the process was completed by smoothing the various sections by means of sandpapers. After the silver had been heated and cleaned for the second time, the separate pieces were welded together.

Ornamentation could now be added to the exterior or, if this was not desired, a long silver chain might be attached to large rings on each side of the case, allowing it to be suspended from the wall.

The forms and designs applied to these *mushaf* cases were generally chosen in conformity with the meaning and contents of the Qur'an. The most commonly used motif was that of a mosque, but such pictures were strongly reminiscent of the work of folk artists, and represented an ideal mosque of the imagination, closely resembling those depicted in the old miniature paintings, rather than any mosque to be found in real life.

Another very common motif was the cypress, the symbol of the eternal character of the word of God as expressed in the Qur'an, and regarded by the Turks as a sign denoting the idea of eternity. Another frequently encountered motif is the star and crescent, the symbol of Islam and Turkish nationhood.

When niello or encrustation was to be employed, the pieces were first of all welded together to form a box. In the case of niello, the design was engraved on the surface of the work by means of steel pens, and the niello either spread or sprinkled over the grooves. The works was then heated to allow the niello to sink into the design and, after being left to settle, the whole was cleaned and any final touches made. The bow might also be decorated by the addition of coins or spangles.

The encrustation applied to *mushaf* cases was usually in the Turkish style. That is to say, instead of sockets for the jewels in the surface of the work, the mounts were prepared in the form of collars consisting of fine sheets of the silver veneer. The stones were then placed in these mounts and either held by plaster or secured by means of claws.

As these *mushaf* cases were normally purchased by people of moderate means, the stones employed in the encrustation were not usually of great value. (In those days the difference in value between gold and silver was not as great as it is today. The difference widened to a marked degree only in the last fifty years.) The stones most commonly employed were the agate, regarded as holy by the Turks, the turquoise, whose color we have always held in very special affection, and coral. Glass of various colors was also employed.

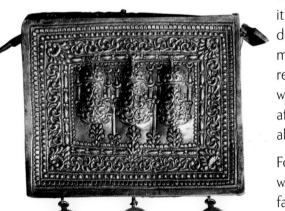

Qur'an case with embossed silver in Istanbul style.

For those who wished their *mushaf* cases, by whatever technique they may have been manufactured, to present a rather grander appearance, the surface of the silver could be plated with a veneer of gold treated with mercury.

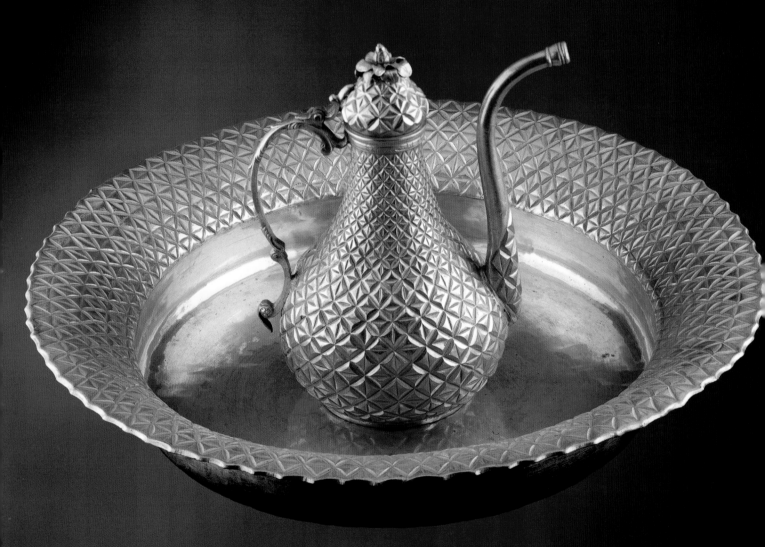

The peak of elegancy

İbriks
(Ewers)

"İbriks" are pear-shaped water containers consisting of a spout and handle, with most having a cap at the narrow neck. According to the dictionary Qamus Uthmani, the original form of the word is "abriz," meaning "one that pours water" in Persian.

The word was passed from Persian to Arabic, and from there to Turkish. Until recent history, it had meant water's final destination on the journey from its source and ending up in our homes. Before water was brought to our homes via pipes, water was carried in pitchers from the horhor fountains to big square-shaped containers in homes or taken from wells, many at great distances, and emptied into different ewers to be used for various purposes.

With its aesthetic beauty and the utility of its purpose, the ewer is a gift to art history from Anatolian Seljuk Turks who were a continuation of the Great Seljuk Empire. Their art showed an enlightened face to the dark Middle Ages as they set up a state in the near east and Anatolia. Seen as a precious jewel, the ewer also found a place in our literature. Renowned poet Nabi wrote these verses for the ewer and the basin, its dirty water container:

Nabi cannot apprehend the Truth of fortune

Çalak on the other hand is very comprehensive

While the ewer and basin are both made from unique minerals

One holds pure and the other contaminated water.

Although similar shapes from minerals and soil have been found in pre-Islamic civilizations, the ewer somehow seemed to give rebirth to the cleanliness ordered in Islam; it seems to take pride in its duty; however, it also struck a humble form alongside its usefulness and beauty.

The ewer was not just a container that held water; with its portability, easy to use aspects, and beautiful shape, it was also one of the essential household goods.

In other words, the ewer was one of the pasts' most beautifully shaped containers and a symbol for hygiene and thriftiness. The Ottoman Turks who valued water saw it as sacred and took great care not to waste a single drop for unnecessary needs.

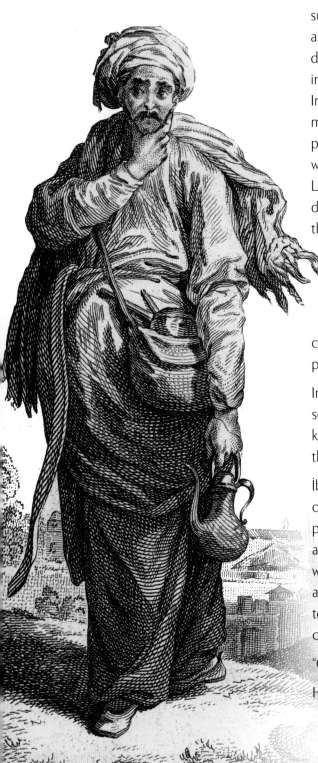

As a result of the value given to hygiene, a class had emerged to supply water used for washing hands and faces, to perform the ablution, and for the Sultan, State notables, and the wealthy to drink. The ones who performed this task were called "İbrikdar" (one in charge of the *ibrik*) or "Seribriki" ("the head of the *ibrik* work"). In addition, there was a Head İbrikdar whose job was one of the most important seven jobs within the harem organization of the palace. All of the work of the harem was done by these foremen whose names were Head Treasurer, Head Storeroom Keeper, Head Laundryman, Head Chef, Head Box-man, and Head İbrikdar. The duties of these people were of great importance and therefore they were highly paid palace workers.

Meanwhile, within the public, this job was done by young people, who pouring water onto the elders out of courtesy; in return, the elder would pray for them. Also, because this job was seen as if it was a part of worship, it would be taught to the children with the right methods. However, the elder would also pour water onto the hands of the young.

Important statesmen would also pour water onto the hands of scholars, as a sign of respect for knowledge. For example, it is known that the Sultan Ahmed I had poured water on the hands of the great Sufi Aziz Mahmud Hüdâî.

İbriks with filtered basins would certainly be present in the homes of polite and well-educated families. A separate filter would be placed on top of the set of basins so that the dirty water flowing after the washing of hands would not be visible. All of these things were thought through to the finest detail. The etiquette of the ewer and its places of use within the home were determined according to principles. Separate ewers and basins were found for guests. In old Turkish homes, there would be a sign addressing guests saying:

"O guest, perform your Prayer, the *qiblah* is in this direction.

Here is the basin, here is the ewer and here is the towel."

Again, according to our traditions, based on the financial status of the family, there would at least be an ewer along with a basin and a full ablution churn was certainly given to the family of the soon-to-be bride.

At first glance, even though ewers may look the same, when observed carefully their shapes and embroideries differ greatly. In Anatolia alone there were more than one hundred different kinds of ewers and they are named after the cities they were made in.

İbriks were made everywhere, but they most known ones were made in Istanbul, Tokat, Malatya, Kastamonu, Sivas, Erzincan, Gaziantep, Siirt, Kayseri, Denizli, and Çorum. Also, it is known that in a single city there could be different methods carried out by different ewer masters. İbriks were mostly made using copper, sometimes the yellow kind, as well as gold and silver.

The making of the ewer was especially an art of shaping and the most important utensils were the hammer and anvil. Excluding the spout, handle, and base, the old masters showed great talent by making the ewer as a uniform structure. Using a steam hammer or an anvil, a circle was drawn with the help of a compass and cut from the plate-shaped copper. The body was made as a single piece from the neck to the base with hammers, and straight and curved anvils, which were used when the copper became hard due to being beat and tempered many times. The ewer would be completed after the base, lid, and spout were made. This method was later abandoned due to the level of difficulty and hardship and was replaced with the method of the body being made from two different parts. The body would later be welded and the neck parts would be added afterwards. If the spinning method with the lathe is set aside, even the masters today follow the second path.

İbriks no longer carry out their old tasks, but they continue to exist as an item of decoration and a sign of the past in Turkish homes. They rest in their corners liked retired civil servants.

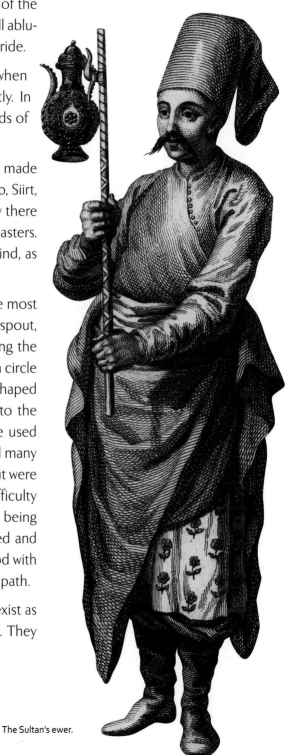

The Sultan's ewer.

111

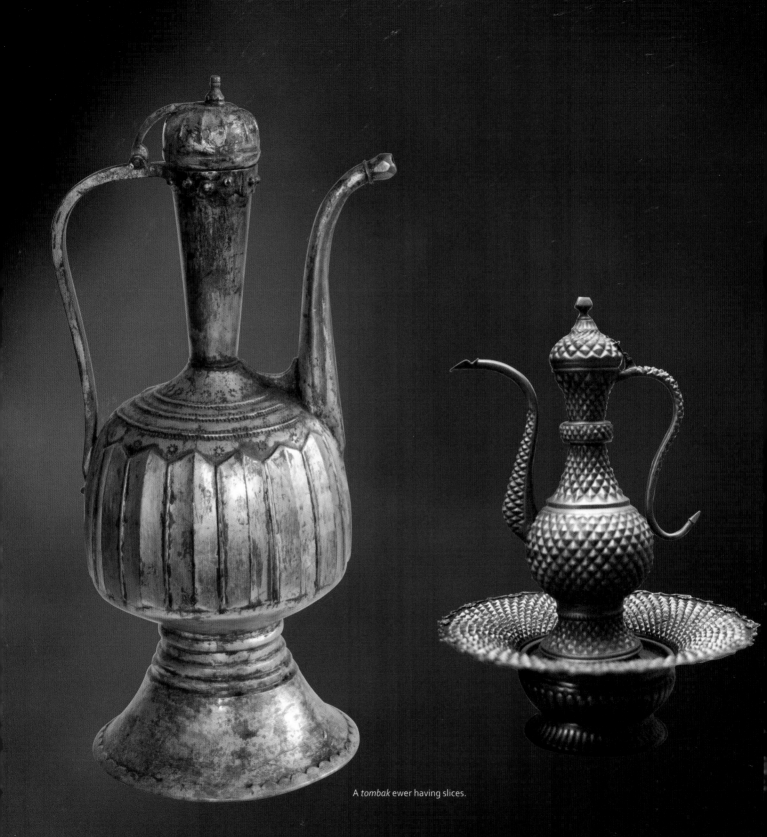

A *tombak* ewer having slices.

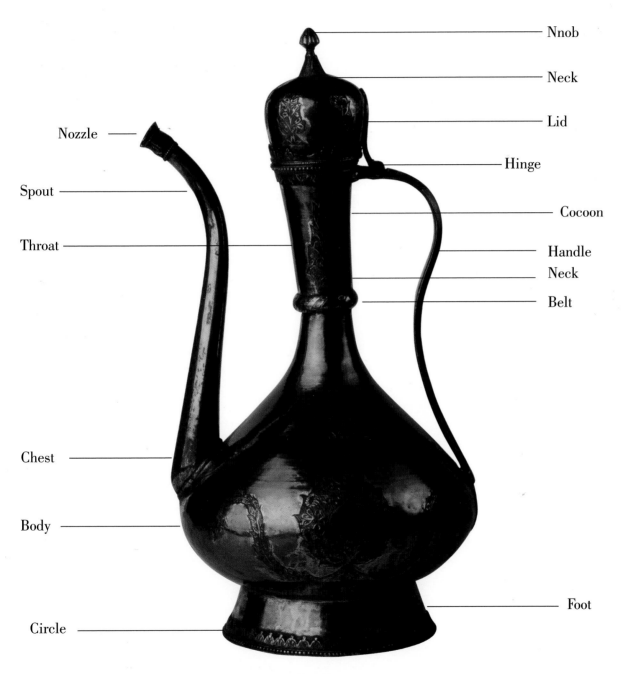

Nnob

Neck

Lid

Hinge

Cocoon

Handle

Neck

Belt

Nozzle

Spout

Throat

Chest

Body

Circle

Foot

Bottom

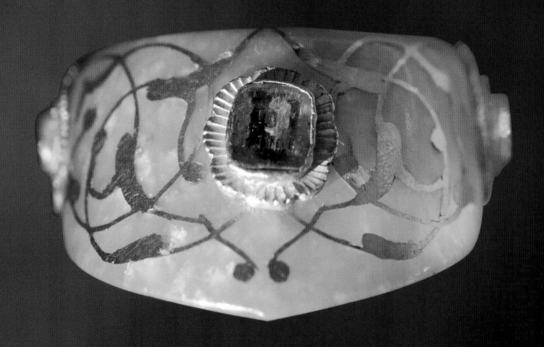

Rings

I like all types of jewelry, rings have a very ancient history. The earliest examples discovered belong to the tribes of Asia Minor or the peoples of Mesopotamia, and were worn by the ruling classes. Their form, size and symbols marked upon them reflected the status of the wearer, and in addition they were a convenient way of carrying the seals which served as personal signatures. Over the thousands of years since the birth of civilization, kings, sultans, viziers, and state officials set their seal to important documents using the seal rings worn on their index finger which bore designs of words and pictures unique to that individual.

Rings used in pre-Islamic eastern societies generally bore figurative designs, but with the advent of Islam opposition to representation of the human form led to calligraphic inscriptions taking their place. So while the seal rings of Western rulers generally featured portraits or figures, those of the Ottoman sultans usually took the form of the *tughra* or imperial monogram, a calligraphic composition consisting of their own names and that of their fathers, and the words "May God render them ever victorious." Rings engraved with minute inscriptions on precious stones and metals by the celebrated engravers of the time number among the most outstanding works of Ottoman craftsmanship. It is regrettable that we do not even know the names—never mind anything about the lives of most of the craftsmen who produced these remarkable works of art.

Silver talisman

To continue the comparison with Western countries, while seal rings there were reserved for the use of high-ranking individuals, in Ottoman Turkey almost everyone—except for peasants and the illiterate who signed with their fingerprint—possessed a seal ring known as "hatemi." From surviving examples it is evident that among the Assyrians, Persians, Hittites, Byzantines, Etruscans. Romans, Seljuks and Ottomans, seal rings were of great importance both in terms of their official Junction and as works of art. Ottoman rings include examples with inscriptions consisting of letters used to express numbers, these generally having a talismanic function designed to protect the wearer from the evil eye and illness.

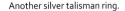
Another silver talisman ring.

115

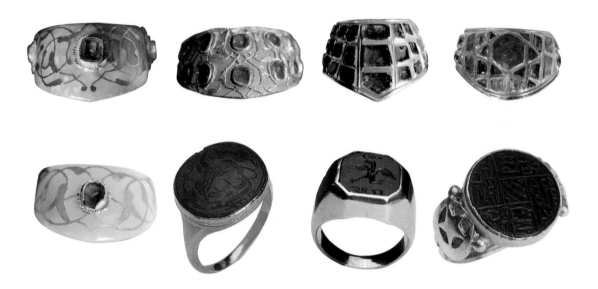

Rings were made of very diverse metals. In Turkish-Islamic society it was usual for women to wear gold and men silver rings, and of course the wealth of the owner also determined whether they wore rings of copper, silver or gold. Often rings were set with precious or semi-precious stones, sometimes left plain and sometimes elaborately engraved. Although stones like emeralds, rubies or chrysolites were sometimes mounted on rings the most common stones were agates, bloodstones, and rock crystal.

Just as "Winds blow where once that sultan ruled," the reign of the art of ring making has come to an end, and its place taken by glittering diamond rings whose value lies only in that of the stones themselves. Men once wore rings as an important symbol of status and individuality, but have now been obliged to give up the custom as a result, so they have been affected more badly than women by the change.

I must conclude by expressing the wish, therefore, that these new mass produced rings might once more make way for rings of character, unique to the individual and reflecting their personality.

Various silver rings ▶

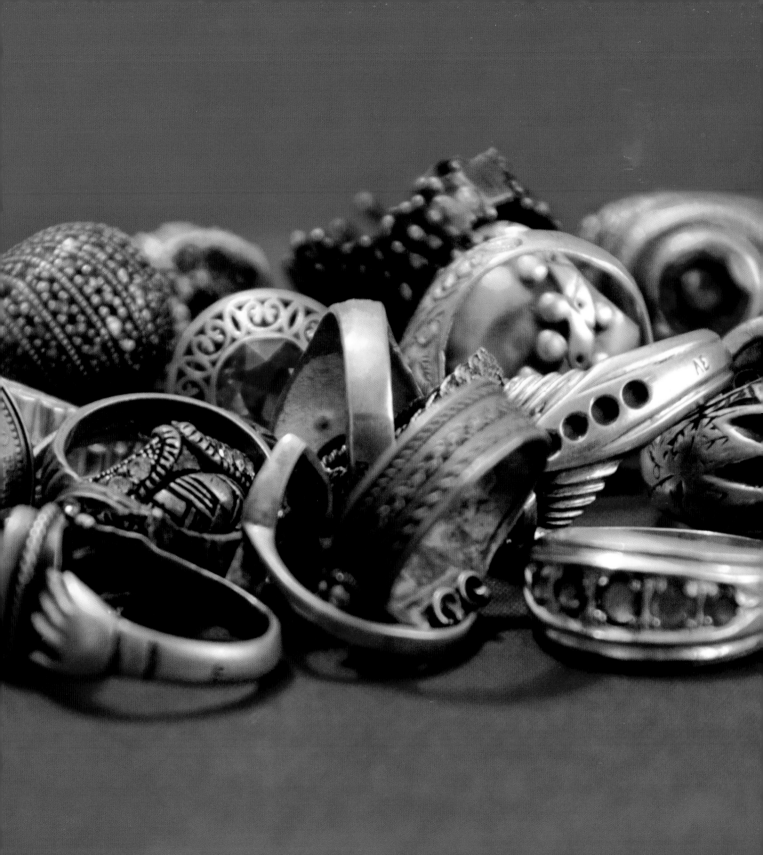

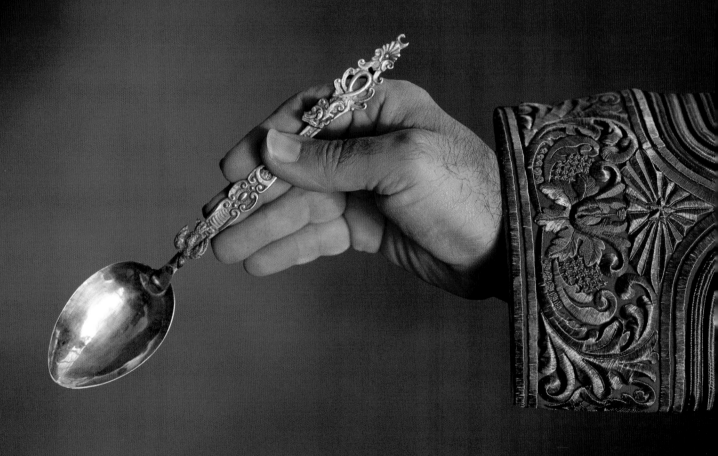

Turkish Spoons and Spoon-makers

"The gate leading from the Bayezid Mosque into the secondhand book market is known as the Kaşıkçılar Kapısı (Spoon-Makers' Gate), and what is now the book market was formerly known as the Kaşıkçılar Çarşısı (Spoon-Makers' Market). Before forks and spoons were imported from Europe, soup-spoons of boxwood and ebony and dessert spoons of ivory were manufactured here."

These lines are taken from the book by Musahipzade Celal entitled Life in Old Istanbul. It was with the Tanzimat movement in the first half of the nineteenth century that we Turks began to repudiate our own art and culture and, as the result of our failure to decide what should be rejected and what retained a great many of our old Turkish arts and crafts, like the spoon manufacture mentioned by Musahipzade Celal, were abandoned and are now almost completely lost in oblivion.

I have every respect for the conception of "Art for Art's Sake," but in my opinion an artistic object is much holier and much more worthy of respect if it also performs a useful function. Spoons have served us for centuries, they play an essential part in the development of the human being, and after the adoption of a settled way of life they became an integral part of our social behavior. A combination of historical knowledge and a lively imagination might help us to guess how spoons assumed their present shape.

Spoons were formed essentially to suit the shape of the mouth and to be easy to hold in the hand. Then aesthetic aspects were taken into consideration, various different materials were employed, and finally extremely beautiful decoration applied by means of a number of different techniques.

Spoons can be arranged in three different groups according to the materials employed:

A. Wooden spoons
B. Metal spoons
C. Spoons of horn, bone and seashells.

Wooden spoons with ornaments.

119

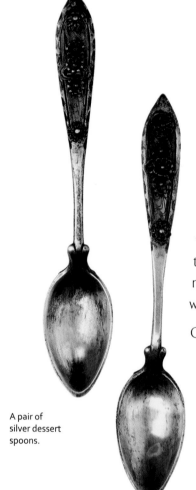

A pair of silver dessert spoons.

A. Wooden Spoons: The first spoons were generally made of wood because of the easy availability of the raw material. Hard, fine-grained, perfumed woods were normally preferred. Wooden spoons were popular partly on account of their cheapness but partly, too, because they don't scratch kitchen utensils. The scratches made by metal spoons form beds for microbes and, in the case of untinned pots and pans, can be the cause of food-poisoning.

The demand created by a rapidly rising population for large quantities of consumer goods made it inevitable that the individually manufactured wooden spoon should be replaced by mass-produced metal ware, though the term "kitchen spoon" still brings to mind the old type wooden implement, which, decorated with painted motifs or literary inscriptions, has now withdrawn behind the glass panels of our sideboards.

On one side of the handles of some of the spoons in my own collection are to be found verses from the folk poets of Anatolia surrounded by painted motifs, while on the other side one can see Ottoman coat-of-arms inscribed with exquisite workmanship.

Wooden spoons were the products of simple tools and skillful hands. The tools consisted of a small adze, beveled knives for shaping the bowl and several saws of different sizes. The wood to be used for the spoon is fired roughly carved to size before being handed over to the master craftsman for the more skilled work of rasping and filing. And here it seems appropriate to quote the old proverb, "Anyone can make a spoon but not everyone can fix the handle."

This indicates that spoon-making is a highly skilled operation. After rasping and filing, the surface is smoothed with glass or sandpaper and, if there is to be no painted decoration, is then coated with shellac. If the spoon is to be decorated it is handed over to another craftsman or sent to a workshop which specializes in applying painted decoration.

B. Metal Spoons

The metal spoons manufactured here until the turn of the century possessed a very real artistic value, but with the flooding of our shops and markets with cheap mass-produced articles from the West this particular skill also completely died out. To return to our subject however,

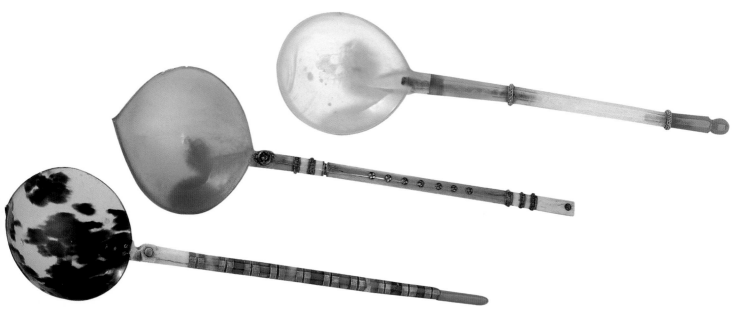

Spoons to drink compote with mother-of-pearl, horn and tortoiseshell bowls and mother-of-pearl and ivory handles, in Istanbul style.

the manufacture of metal spoons began to spread after the discovery of the technique of casting metals. Wooden molds are prepared and the metals to be used (gold, silver, brass, etc.) poured into them. After being removed from the mold, the metal is cleaned, filed and smoothed, and then lent whatever elegant shape may be desired. Finally, decoration may be applied to any part of the spoon (normally the handle) by one of the following methods:

1. Studding with precious or semi-precious stones such as emeralds or agates.

2. Sevad applied to the handles, particularly of gold and silver spoons.

3. Filigree decoration made by fretsaw inserted into a hole bored by means of a gimlet.

4. Motifs, lettering and patterns engraved by means of steel pens.

5. Filigree decoration inserted into openings in the handles.

All these various methods require great skill, technical expertise and mastery of the craft. (As I have already treated the above-mentioned techniques in detail in previous articles I shall refrain from going into further detail here.)

C. Spoons made from bone, horn and seashells.

These spoons are generally employed for particular types of Turkish sweets such as *aşure* and *sütlaç*. Although some spoons of horn or ivory are made in a single piece, in most cases the bowl and the handle are made separately and fitted together by means of gold, silver or brass nails. To prevent the spoon from harboring microbes great care is taken to ensure that the bowl is perfectly smooth and flawless. In contrast to this, the handles are very ornately decorated. Although the bowls of all types of spoons are hollowed out elliptically, the actual depth of the hollow depends on the type of food for which the spoon is to be used. Bowls are usually made of ivory, horn, bull's hora and coconut.

Skill in spoon-making was most strikingly displayed in the fashioning of the handle. Those with spiral decorations particularly are exquisite, and while some handles simply reflect the qualities of the material of which they are made, others are decorated with an inlay of some other material such as ivory, horn or coral. Handles made of materials such as bone, horn or ivory are usually inlaid in metal with rings of mother-of-pearl, coral and various metals set in the intervals between them and a piece of coral at the very end. Very beautiful specimens of these types of spoon can be seen in the Topkapı Palace Museum, as well as in a number of other museums and private collections.

Let me end with this motto to be found written on the handle of a wooden spoon: "This spoon is a beautiful spoon and not to be dipped in dirty dishwater."

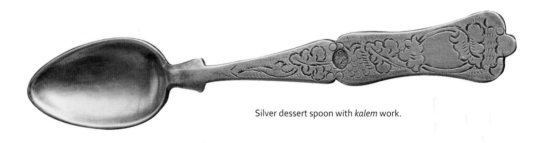

Silver dessert spoon with *kalem* work.

The dining table of Sultan in a miniature painting. ▶

122

Old Turkish Door Knockers

Until the advent of electric door bells every house had its door knocker and every person their characteristic knock. Do not imagine that I am about to mourn the disappearance of the door knocker. I am not one of those who assume that everything in the past mas admirable per se. However, I do regret the way that art has been alienated from our daily lives in the name of practicality and modernity.

The traditional door knockers which blacksmiths and metal casters made in Turkey for centuries heralded the arrival of visitors. From the tone of the knock, ranging from violent to courteous, the household got an idea of whether the comer was just a neighbor dropping by or a bringer of bad news. Before most of us began living in flats instead of detached houses with their own gardens, door knockers were a decorative feature of the main gate in the garden wall.

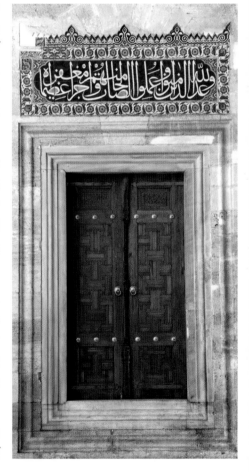

So that the women and children of the household did not have to knock each time they wanted to be let in, the gate was fitted with a latch called a *şıpdüşen* or *şıkdüşen*. When I was a child / loved playing with the latch and hear the loud click it made as it fell. Years later I found one of these old-fashioned latches at a scrap market in Konya, and it made me as happy to touch one again as if I bad come across a childhood friend.

Every region and every period had its own characteristic door knockers, which are lovely examples of both workmanship and traditional Anatolian culture. The majority was made of iron, bronze or brass, and the knocker itself frequently incorporated the animal figures which are a distinctive feature of Turkish art. The back plate mas usually engraved with geometric designs.

Door knockers have largely been ignored by scholars researching Turkish architecture. Yet, for both the Seljuks and Ottomans the details of work of

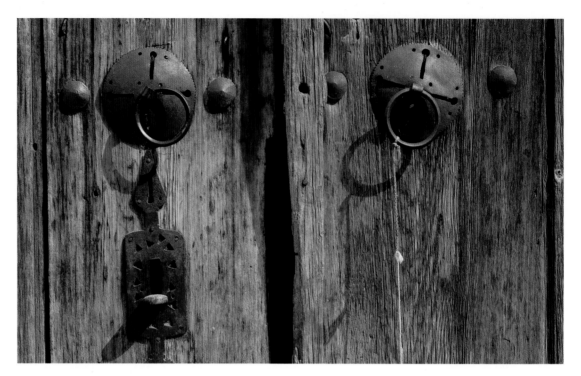

art were always of equal importance with the whole. For that reason, the door knocker alone gives the knowledgeable observer an idea of the concept behind great monuments such as the Selimiye, Süleymaniye or Sultanahmet mosques.

During the early stage of their careers, Ottoman architects learnt to perfect detail in small buildings, and only after they had become masters of these were they let loose on steadily larger buildings, until the best among them finally rose to the position of the chief architects who designed major monuments. One such example was the 17th-century chief architect Sedefkar Dalgıç Mehmet Agha, who designed Sultanahmet Mosque.

In both Seljuk and Ottoman architecture doors were the focal point of the exterior. Indeed, for the Seljuks, portals were treated as monuments in themselves.

Since doors were regarded with such importance, it was natural that everything connected with them should reflect the same attitude. So when you next visit a historical Turkish building, first go straight to the door to inspect the door knocker, lock and key, and you will be surprised at the fascinating discoveries you will make.

Forged-iron door knockers.

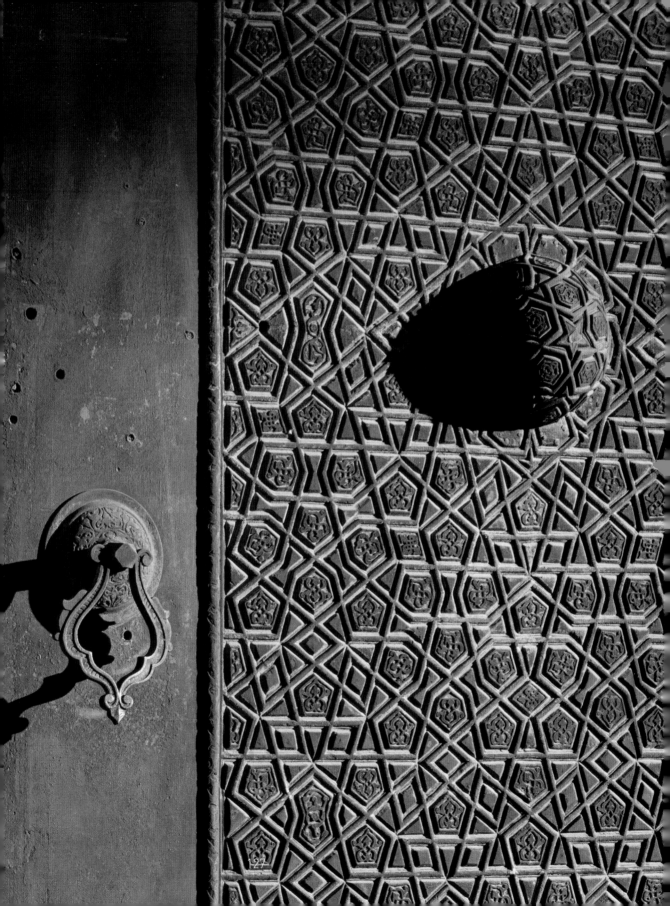

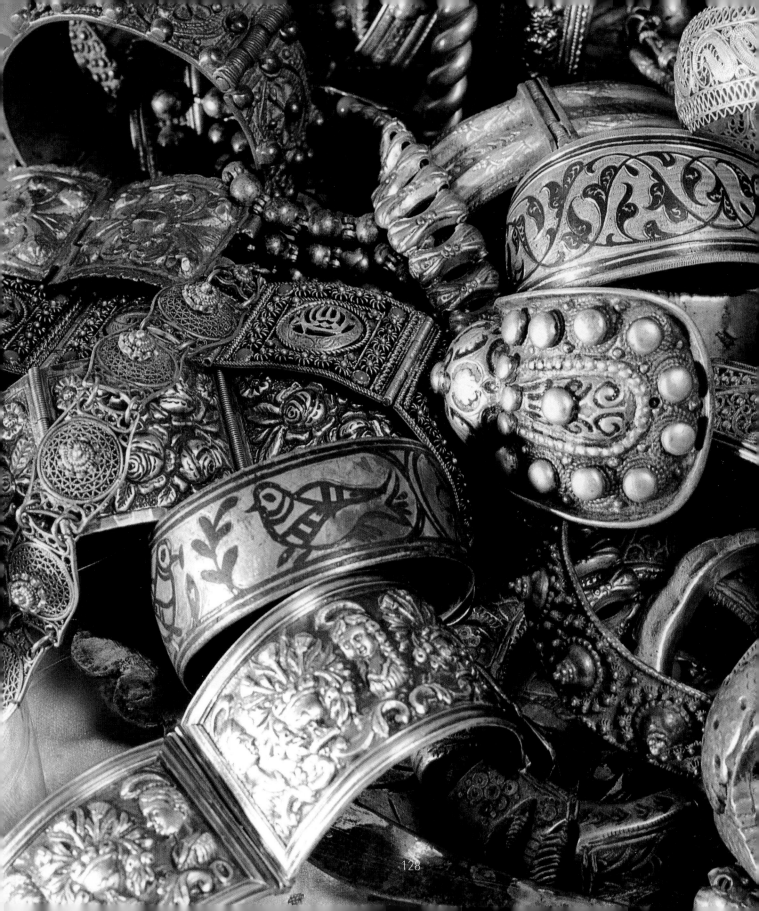

Turkish Bracelets

The bracelet is a very ancient form of human adornment, and the designs of the earliest surviving examples suggest that, like so many other types of jewelry, they were originally a form of talisman or magic charm. The first bracelets were made of wood, stone, and soft metals occurring naturally in their metallic State, primarily gold and copper. As technology developed over the millennia it became possible to extract and work silver and other metals. Today bracelets are as popular as ever. Stylistically they fail into two categories, what we might call the classical imitating old forms, and modern designs in abstract and original styles.

All women, from the queen in her palace to the rural woman in her cottage, whatever their income or cultural level, have always enjoyed wearing bracelets. However, apart from their decorative qualities, bracelets have had other functions. For example, copper bracelets are still believed to relieve pains in the joints, and in former times, bracelets containing agate, a stone regarded as sacred amongst the Turks, were believed to protect the wearer against bites by venomous animals. Bloodstones, meanwhile, were believed to stop bleeding.

Gold bracelets studded with precious stones were preferred by the wealthy, but silver was also used to make some of the finest bracelets in which the colored stones showed up against the white metal to wonderful effect. Silver puts up with the forging process with all the patience of a dervish suffering oppression and deprivation. When red hot it is drawn out into wire, or placed on a bed of pitch and designs hammered into the surface. Studded with stones, patterns chiseled out for niello designs, gold plated using mercury, or decorated with tiny silver drops to produce the jeweled effect known as *güherse*, the bracelet completes its trial by fire on the forge and is ready to encircle the wrist of a loved one.

A wide range of other techniques are used to make or decorate silver bracelets One o] the loveliest is filigree, and similar types woven with circular or flat silver wire. Another is engraving Often two or more techniques are combined in a single bracelet, and some techniques are associated with the place where they are commonly made, such as Trabzon basin—a type of filigree bracelet, Kayseri *burması* and Halep work.

Embossed silver bracelet with a tulip ornament.

Although in the past hundreds of different types of bracelet were made, often the same craftsman making several types or developing innovations of his own, relatively few antique Turkish bracelets have survived. Even the names by which they were known are often not remembered today. As well as types known after the cities where they were most commonly made, there were names describing the forms, such as *kabara* (boss), *kubbeli* (domed), *zincirli* (chain), *koruklu* and *tanklı* (also known as *başçavuş*) bracelets.

Bracelets worn around the ankle are called *halhal*, an Arabic word meaning ankle. These are worn in many countries from Africa to India, including the eastern and southeast parts of Turkey. Traditionally halhal were made from a string of hollow spheres containing tiny metal beads, so that they made a pleasant tinkling sound as well as looking attractive. Rural women used to have halhal made for their children so that when they were busy working in the fields and orchards they could hear where they were playing even when they were out of sight, and would be warned by the sound if they strayed off.

So there is more to bracelets than meets the eye, and some knowledge of their techniques and the origins of their designs reveal them to be far more fascinating than just pretty objects.

Embossed silver bracelet.

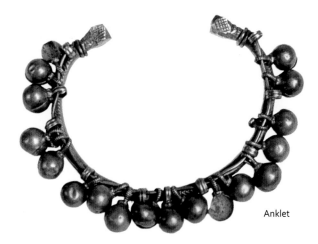

Anklet

130

Various bracelets. ▶

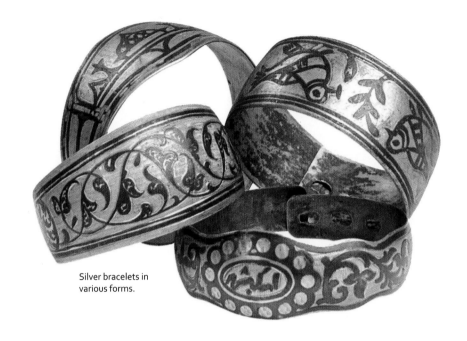

Silver bracelets in various forms.

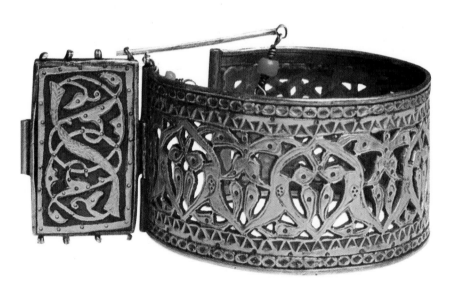

Enameled and open-work bracelet.

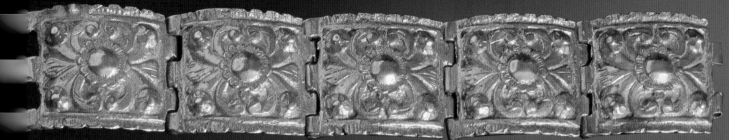

Casted and gold plated bracelet, in Istanbul style.

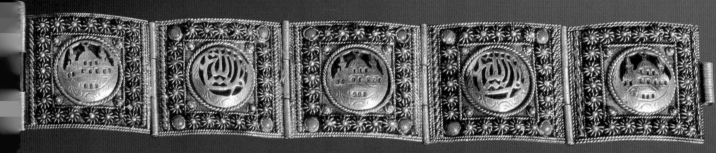

A bracelet of the recent past.

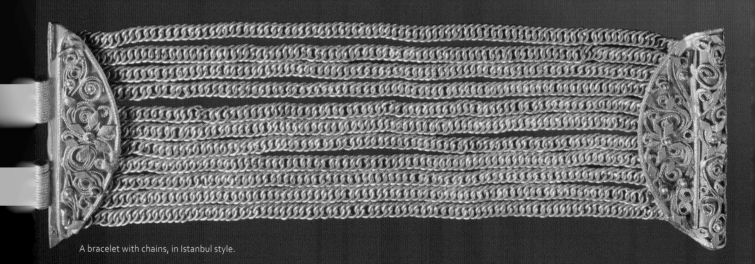

A bracelet with chains, in Istanbul style.

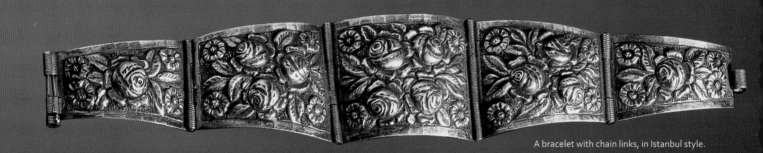

Embossed silver bracelet, in Istanbul style.

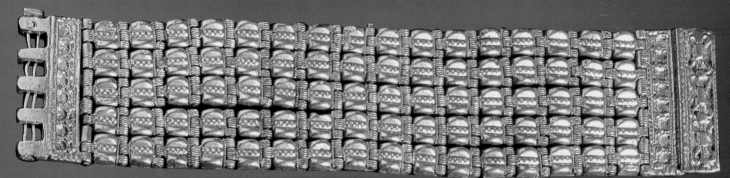

A bracelet with chain links, in Istanbul style.

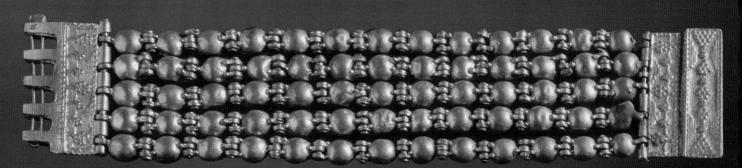

A hobnailed bracelet, in Istanbul style.

From Imagination to Reality

Karagöz:
Turkish Shadow Play

It is not known how, where, and by whom "shadow play," a type of art peculiar to the eastern region of Turkey, first emerged. There are various claims about its origin, with some saying it first originated in China and others claiming it emerged in India and passed over to Java.

According to one story, Chinese Emperor Wu, who lived two centuries before Christ, lost his beloved wife. Wu was so overcome with sorrow that no one was able to comfort him. Then, an artist consoled Wu by making a puppet of his deceased wife and reflecting her appearance upon a curtain.

The story of the Turkish Karagöz Play is similar to the one mentioned above. When the second Ottoman Sultan Orhan saw that the construction of the Bursa Grand Mosque was progressing slowly, he asked the reason behind this. He was then informed that Karagöz the blacksmith and Hacı Evhad the foreman had been distracting the workers by telling humorous jokes and acting silly. The enraged Sultan ordered both of them to be killed. After a while, however, the Sultan started to regret his act and was very upset. To console him, and artist known as Sheik Khushtari created leather puppets resembling Karagöz and Hacıvat and, in a sense, gave life to these two charming fellows.

It is not known whether there are any documents confirming the first story, but with the Grand Mosque, the grave of Karagöz, and Sheik Khushtari have been commemorated to this day. Thus, we can confirm the "Karagöz Incident" in Turkey.

Before Turks converted to Islam, they were followers of Shamanism, which included rituals that were done around a fire. The shadows that appeared of the people and the objects in their hands were most likely a source of inspiration for "shadow plays." It is known that Turks did not completely abandon their previous traditions, yet adapted them to the Islamic tradition and continued to practice them in a way

Karagöz for show only.

that was not contrary to the obligations of religion. Turkish wit has helped find this topic a place in mystic thought and the Karagöz play, which very few people know the true purpose and meaning of, has survived for centuries and made it to present day with its entertaining and didactic aspects. The following is an example of a ode:

This screen is a tapestry for the eye of the seers.
A portrayal of truth for the expert of signs.
By imitating the universe, Sheik Khushtari set up this curtain,
And portrayed all sorts by likening, beware.
What the cosmos beholds is unknown but this is real.
The world speaks the truth through its general disposition.

Many a meaning is present on the throne of the earth, observe,

For only the experts may comprehend the hidden meanings.

When the light goes out man vanishes mysteriously,

A fine sign that the world is not eternal.

The last verse of the ode shows how "the sudden disappearance of the people after the light turns off is a great example that portrays this world is transient." This is an example of the descriptive narrations that are frequently encountered in mystic philosophy. There is even a story about it that is attributed to Sheik Khushtari:

"Khushtari, who came to Bursa from the town of Khushtar in Bukhara and settled in the area near the Grand Mosque, was one of the sheiks of the Naqshibandi order. One day, his students asked him to tell them about the human body. Khushtari took off his turban and unwrapped it. He nailed it from its four corners against a corner and lit a candle behind it.

He then said, 'This curtain represents the world.' Then, he put his hand against the back of the curtain and said, '... and this is humankind. The burning light is the spirit. As long as the spirit is still there, humans continue to live in this world.' He then

Ⓩ Karagöz.

blew the light out. 'When the light goes out, the body is lost. However the curtain, in other words the world, stays.'"

The Karagöz plays, which were played at circumcision feasts to entertain children, had an important place in Turkish social life until recent history. The public would enjoy the plays, and most would learn while having fun.

Along with entertainment, there were also educational messages conveyed in Karagöz plays. For example, the fact that green timber should not be felled, lovers should not split up, advice against bad manners, and the dangers of drunkenness are all touched upon in Karagöz plays like "Kanlıkavak," "Ferhat and Şirin and Tahir and Zühre," "Çifte Hamamlar (Double Hamams)," and "Karagözün Gelin Olması (Karagöz Becoming a Bride)." In "Kütahya Çeşmesi" (The Fountain of Kütahya), the dangers of gossip are told.

The Karagöz plays were versatile works of art in which people's daily lives were intertwined with social problems and decorated with humorous and odd scenes. These plays were more than just plays, sometimes filling the role of television and frequently taking the place of "public theater."

The Making of Karagöz Figures

The making of the more than two hundred various types of Karagöz figures required quite a lot of effort. Both sides of a half raw piece of hide, whose hairs were removed and then tanned, were scraped with a thin piece of glass until the leather was transparent. Then, using a copying pencil and special blades, the figure was carved out of the leather with the help of its previously made stencil. Afterwards, a curved knife called a "Nevgergen" was used to punch holes into the edges of the clothes of the puppet, row after row punched in order to let light through. After this process had been completed, the clothes were dyed using "kök boya" (madder), which penetrated the leather and was transparent. In order for the figure to be better seen on the screen, the outer contours were outlined in black. The movable parts were sown together. Depending on the degree of mobility of the figure, a "rod hole" would be pierced at a certain point in the body to keep it balanced and a piece of leather was attached as a reinforcement to prevent the rod from loosening the hole. The completed figures were then slightly lubricated to prevent cracking and to gain a little more transparency, and, finally, they were ready for the play.

Hacıvat.

137

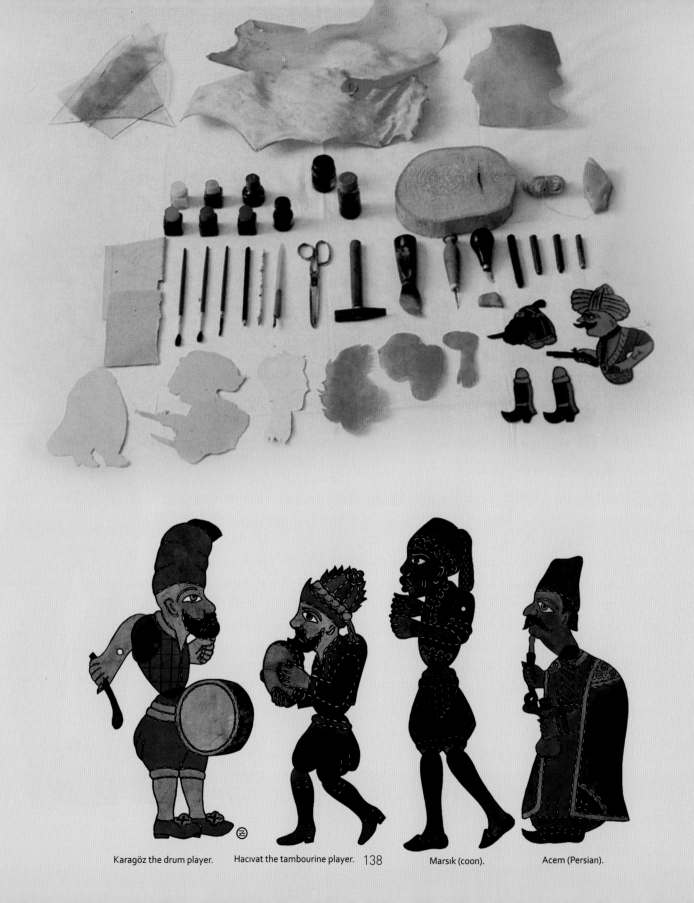

Karagöz the drum player. Hacıvat the tambourine player. 138 Marsık (coon). Acem (Persian).

Today, the makers of Karagöz figures consist of only a very few number of amateurs. No other skilled puppeteer has emerged after the last great puppeteer, Hayali Küçük Ali (Mehmed Muhittin Sevilen). Furthermore, the plays only audiences consist of the only beings capable of laughing and thinking: kids.

However, the Turkish Shadow Play Karagöz, which makes its audience laugh and think and always teaches a lesson, is an impeccable style of art that has been passed down from previous generations. With the use of irony and humor, its main purpose is to convey the societal issues of each era through the speech of characters from various factions of society. In this regard, the Karagöz plays, which allow society to be able to laugh at itself, are still viable and even universal because of humankind's certain unchanging characteristics.

Note: The Karagöz figures on this page were made by the author himself.

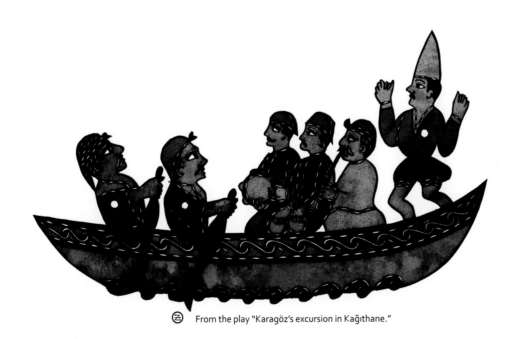

From the play "Karagöz's excursion in Kağıthane."

Noble mud

Tophane Pipe

As the Turkish poet Cahit Sıtkı Tarancı once wrote:

How much a person changes with the years!
I cannot find myself in any picture I look at!
It is a lie that I am indifferent, a lie!
Our first love is of vague, indefinable things.
Even the memory is alien to us.

But is it only man who changes with the years? Or is it because man changes that everything else changes? As long as the world keeps turning everything will keep changing, and it is right that this should be so. But should these changes lead to a rejection of the past? Should the past be erased and forgotten as if it had never been?

It is for that reason that our museums are filled with objects that are absolutely alien to us. We know neither what they are, why or how they were made, or who used them.

Clay pipes come into this category. We do not even know definitely where the clay used in their manufacture was found. These pipes continued to be made until 1928, after which they completely disappeared.

The clay pipe makes a noxious substance namely tobacco, more pleasing, but it is a fact that it also makes it less harmful. At the present day we always have a packet of cigarettes at hand. There is nothing to prevent us from drawing one out and lighting it with the blind reflex of an automaton and drawing the noxious smoke down into our lungs. It gives us little pleasure and does us a great deal of harm.

Christopher Columbus, who discovered America in 1492, informs us that tobacco was used by the natives of Central America. About that time, a sailor sent a specimen of the weed he had obtained in the Tobago Islands to a European merchant by the name of Petrus Marten, thus introducing tobacco

into Europe. By 1560 Europe was swarming with tobacco addicts.

Tobacco began to be smoked in Turkey during the reign of Sultan Murad III. Prohibitions were issued on several occasions because of the danger to health, and because it was believed to have been the cause of the great fire that reduced a third of the Fatih district and its surroundings to ashes in 1637. Sultan Murad IV felt no compunction in having those who defied the prohibition summarily executed, and there is a very famous story relating an incident involving Sultan Murad IV and the 16th century geomancer (Remmal) Ahmed Çelebi.

Murad IV often roamed around the city in disguise, and one day he got into a boat at Üsküdar dressed as an ordinary tradesman. Ahmed Çelebi happened to be in the same boat, and he and the Sultan soon got into conversation.

"What is this Sultan of ours going to do next?" exclaimed the disguised Murad. "We had only one pleasure, tobacco, and he's gone and forbidden it!"

So saying he took a pipe out of his sash and proceeded to fill it.

"You look a bold, manly fellow!" he said to the boatman "And you," he said, turning to Ahmed Çelebi, "look quiet and inoffensive enough. I'm sure you won't object to my having a pipe."
So saying, the Sultan lit up his pipe and began to smoke.
"My son," said Ahmet Çelebi, "why don't you give me a draw?"
"And don't forget me too!" added the boatman.
"My son," said Ahmet Çelebi, "What do you do for a living?"

"I'm an old clothes merchant," answered the Sultan. "And what do you do?"

"I'm a geomancer," answered Ahmet Çelebi.

"In that case," said the Sultan, "Let me see if you can tell me where Sultan Murad is at this very moment!"

The old man took out a piece of paper and began making his calculations.

"He appears to be on the water," he announced.

"Look again," said the Sultan, "and find out if he's near or far away."

Ahmed Çelebi made some further calculations and then, trembling with fear,

"My son," he said, "The Sultan is with us here now at this very moment! As I know I'm the geomancer Ahmet Çelebi, that means either you or the boatman!"

Tophane pipe smokers in the Pierre Loti Café in Eyüp.

Thereupon Murad IV rolled up his sleeve and showed him the imperial armlet.

"And now, Geomancer Ahmet Çelebi, try your skill again and tell me through which gate I am going to enter the city. If you guess correctly you'll be pardoned. If not...!"

"Very good, my Lord," answered the geomancer, "but I have one condition."

"And what is that?" asked the Sultan.

"I will find out which gate you'll enter the city by. But I shall write the name of the gate on a piece of paper, and you won't read it until we are actually in the city. If I fail you will have my head!"

A cup with Bektashi crown of 12 strips and its holder.

"Agreed!" said Murad, laughing. Ahmed Çelebi wrote a few words on a piece of paper, folded it carefully and handed it to the Sultan.

"Make for the Langa gate!" Murad ordered the boatman.

As soon as they arrived at the Langa gate the Sultan sent word to the guardhouse to dispatch workers and master craftsmen, and within a few hours a new gate had

143

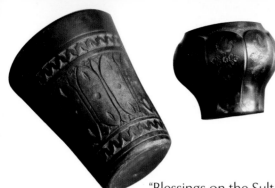

been opened in the city walls. On entering the city the Sultan triumphantly unfolded the paper Ahmet Çelebi had handed to him but was utterly amazed to read:

The Tophane cup in black mud and an inkpot for engravers.

"Blessings on the Sultan's new gate!"

Thereupon Murad pardoned both the geomancer and the boatman, making them the only people to have smoked and escaped with their lives during those years of strict prohibition.

And now let us turn to the art of the clay pipe, which is the real subject of this article.

In the old days the Turks transformed smoking, like everything else they touched, into an art. Smoking, as a cultural institution, became as famous as Turkish coffee drinking.

First of all, the clay, obtained from a quarry in the vicinity of Anadolu Hisarı, was taken over to a workshop in the Street known as Lüleci Hendek in the district of Tophane. Here, in the damp basement of the workshop, the clay was washed, ground, sieved, soaked, kneaded and beaten on a marble slab. Then began the second stage in the manufacture of the clay pipe.

The manufacturing process might well be regarded as a combination of small-scale ceramic sculpture and the art of decoration. If the craftsman wanted to make an original sort of pipe he would first of all prepare a model in wood or ordinary clay. Then, using this model as a female mold, he would hollow out the boxwood mold with steel punches and then hinge this double-sided mold from below. The hinge was very important in allowing the work to be carried out quickly and in preventing any movement between the upper and lower sections of the mold. The craftsman would then squeeze mud of the right viscosity into the mold he had prepared and then, before opening the mold, would scoop out the bowl, thus producing something resembling a very small, fine cup. A passage would then be opened along the center of the stem using a wooden stick. After all, this had been completed the mold was opened, the pipe removed and left for some time. The pipe would lose some moisture during this rest period and exquisite forms and motifs could now be engraved on the surface using small boxwood pipes. These forms and motifs could be applied separately or combined to form a composite whole.

The most commonly used of these motifs were tobacco leaves, stars and crescents, the Ottoman coat-of-arms, and tulip and rose motifs. This work was sometimes carried out by wood-engravers, sometimes by the pipe-maker himself. Finally, these lovely specimens would

be stamped with the name or cognomen of the craftsman.

Now we come to the firing, which is the most crucial stage of the whole process. The pipe is fired in special ovens heated by wood, and if it should happen to crack all the craftsman's work will have been in vain.

Having worked for years with the master craftsman and having reached the conviction that at last he has learned his trade, a young apprentice will ask permission to leave, before girding on the *peştemal*, and set up on his own. He prepares his tools and everything he needs and begins to work. And then he finds that every pipe cracks as soon as he removes them from the oven. He tries to think what he is doing wrong, but he finds himself completely at a loss. He is ashamed to ask his master. But there's no alternative. He reluctantly returns to his old workshop, asks forgiveness, and explains the problem. "Now watch carefully!", the master craftsman says to his old apprentice and as he takes each pipe out of the oven with loving care, he first of all blows on it before arranging it with the others on the bench. The point is that if the pipe is immediately exposed to cold air after being removed from the oven it will tend to crack.

The craftsman prevents this by seeing that it first of all comes into contact with the warm air from his mouth. So the firing process ends with a caress and a loving puff. (The same applies to cup manufacture.)

Although at first glance clay pipes look all very much the same, actually there are hundreds of varieties. Particularly beautiful are the ones with gold leaf decoration and those polished to give a brilliant gloss.

The clay used in making these lovely pipes is known as pipe-clay, and pipes made in various parts of the country are named "Tophane pipes" after the famous pipes made in the Tophane district of Istanbul.

Not so very long ago, fifty years perhaps, there were over fifty workshops making clay pipes in Tophane. But in spite of the increase in the use of tobacco, the old art of clay pipe manufacture succumbed to a misconceived process of Westernization and the abolition of import tariffs.

The clay pipes with the lovely jasmine stems that used to be bought by the dozen and kept in crystal boxes to be offered to visitors in the mansions and palaces are now only to be seen in engravings of old Istanbul.

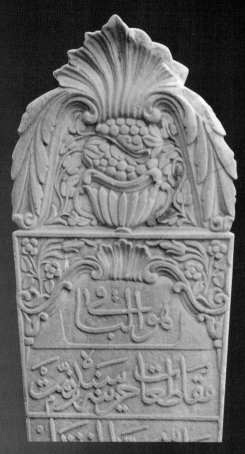

Turkish Tombstones and the
"Huwa'l-Baqi"
(He Is The Everlasting One) Inscription

Artists and art-lovers from all over the world with an interest in oriental art make no secret of their deep appreciation and admiration of Turkish calligraphy.

I remember a story told me by an elderly gentleman during one of my visits to the second-hand bookshop market at Beyazıt when I was still a schoolboy.

It was the story of a foreigner looking round the second-hand bookshops (and no lover of art ever comes to Istanbul without paying a visit to these shops) and seeing a piece of writing on the wall of one of them that immediately took his fancy. The shop-keeper was obviously very unwilling to sell it, but as he couldn't communicate with the

Style : *Jeli thuluth*
Calligrapher : Hasan Çelebi
Date : 1400 A.H. (1982 C.E.)
Inscription : *Huwa'l-Baqi*
Meaning : He is the Everlasting One

Style : *Jeli kufi*
Calligrapher : Ebuzziyâ Tevfik
Date : 1327 A.H. (1909 C.E.)
Inscription : *Huwa'l-Baqi*
Meaning : He is the Everlasting One

Style : *Jeli thuluth*
Calligrapher : Mehmet Aziz
Date : 1328 A.H. (1910 C.E.)
Inscription : *Huwa'l-Baqi*
Meaning : He is the Everlasting One

Style : *Jeli kufi*
Calligrapher : Professor Emin Barın
Date : 1404 A.H. (1984 C.E.)
Inscription : *Huwa'l-Baqi*
Meaning : He is the Everlasting One

Style : *Jeli thuluth*
Calligrapher : Mehmet Şevket Vahdeli
Date : 1270 A.H. (1863 C.E.)
Inscription : *Huwa'l-Hayy*
Meaning : He is the All-Living One

Style : *Jeli thuluth muthanna*
Calligrapher : İsmail Hakkı Altunbezer
Date : 1363 A.H. (1945 C.E.)
Inscription : *Huwa'l-Baqi*
Meaning : He is the Everlasting One

Style : *Jeli taliq*
Calligrapher : Hulusi Effendi
Date : 1336 A.H. (1918 C.E.)
Inscription : *Huwa'l-Baqi*
Meaning : He is the Everlasting One

Style : *Jeli thuluth muthanna*
Calligrapher : Savaş Çevik
Date : 1404 A.H. (1984 C.E.)
Inscription : *Huwa'l-Baqi*
Meaning : He is the Everlasting One

Style : *Jeli thuluth*
Calligrapher : İsmail Hakkı Altunbezer
Date : 1363 A.H. (1945 C.E.)
Inscription : *Huwa'l-Baqi*
Meaning : He is the Everlasting One

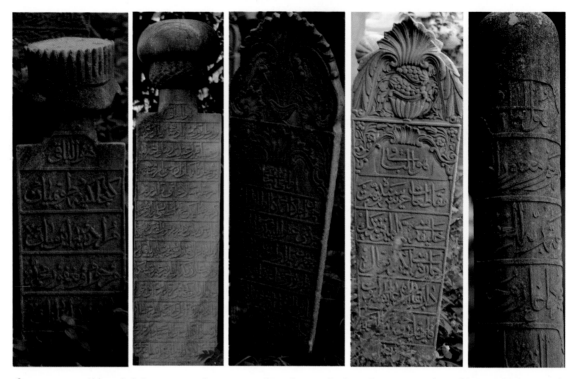

foreigner and he didn't want to disappoint him he ended up by saying that if he really wanted it so much he could have it. The foreigner was overjoyed at being able to purchase this lovely piece of calligraphy, and took it back with him to his own country. Sometime later he invited a Turk, who happened to be able to read the old script, to his house. Seeing his guest looking at the writing on the wall with a broad smile on his face he told him with great enthusiasm how he succeeded in buying it, adding, "But I have no idea what it means!" Whereupon the visitor, still smiling, explained that it meant, "To the toilets!" The host himself now burst into laughter. "It doesn't matter what you write in that script," he said, "It's still beautiful!"

The work produced by Turkish calligraphers in the old Turkish script inspires the admiration of the connoisseur and the man in the street, the expert and the amateur, the Muslim and non-Muslim alike.

Another sphere in which this beautiful old writing is displayed is our old cemeteries. Here it is possible to observe the various types and varieties of script as they develop through the course of history, and my reason for concentrating on the single inscription *Huwa'l-Baqi* which is to be found carved on these stones is to reveal the wealth of composition in Turkish-Islamic calligraphy.

We usually see gravestones from some distance, but if we come nearer and examine them

Style : *Jeli thuluth*
Calligrapher : Unknown.
Date : Unknown.
Inscription : *Huwa'l-Baqi*
Meaning : He is the Everlasting One

Style : *Jeli thuluth*
Calligrapher : Mustafa Halim Özyazıcı
Date : 1377 A.H. (1957 C.E.)
Inscription : *Hu*
Meaning : He

Style : *Jeli taliq*
Calligrapher : Necmeddin Okyay
Date : 1362 A.H. (1941 C.E.)
Inscription : *Huwa'l-Baqi*
Meaning : He is the Everlasting One

Style : *Jeli thuluth*
Calligrapher : Unknown.
Date : Unknown.
Inscription : *Kullu man alayha fan.*
Meaning : All that is on the earth is perishable.

Style : *Jeli thuluth*
Calligrapher : Unknown.
Date : 1391 A.H. (1971 C.E.)

Style : *Jeli thuluth*
Calligrapher : Hâmid Aytaç
Date : 1378 A.H. (1958 C.E.)
Inscription : *Kullu man alayha fan.*
Meaning : All that is on the earth is perishable

Style : *Jeli kufi*
Calligrapher : Unknown.
Date : Unknown.
Inscription : *Huwa'l-Baqi*
Meaning : He is the Everlasting One

Style : *Jeli thuluth*
Calligrapher : Sâmi Effendi
Date : 1321 A.H. (1903 C.E.)
Inscription : *Kullu man alayha fan.*
Meaning : All that is on the earth is perishable

Style : *Jeli diwani*
Calligrapher : Professor Ali Alparslan
Date : 1404 A.H. (1984 C.E.)
Inscription : *Huwa'l-Baqi*
Meaning : He is the Everlasting One.

more closely we find ourselves in a completely different world and in the presence of a masterpiece of rare beauty. Our old calligraphers would carve verses from the Qur'an, the traditions of the Prophet and the sayings of the sages in hundreds of different exciting, imaginative, and uniquely original compositions.

The works of these celebrated old Turkish calligraphers now adorn the walls of our museums, private collections and private houses as well as the tombstones in our cemeteries.

The phrase *Huwa'l-Baqi* occupies a unique place amongst all these various inscriptions. Only *Basmala* could have been written so often in so many different types of compositions as *Huwa'l-Baqi*.

The ability to present the same words in such a variety of lovely forms is the aspect of the old calligraphic script that attracts and fascinates all who take an interest in it.

First of all, however, I should explain the meaning of the phrase and say something about how long it has been used on Turkish tombstones.

The syllable "Hu" stands for God, while "Baqi" refers to a state or condition of permanence. It is the opposite of "fana," or transitoriness. *Huwa'l-Baqi* means that while everything on earth is transitory and fleeting, God alone is permanent and everlasting.

It became a tradition among the Ottomans to inscribe the phrase *Huwa'l-Baqi* on their tombstones. This was carved at the top of the inscribed section of the tombstone, just below the turban, fez or (in the case of a woman) the bouquet of flowers, and was set in a separate frame formed to suit the particular type of composition chosen.

Now let us take a stroll through some of the old cemeteries in Istanbul. After having collected enough varieties of the *Huwa'l-Baqi* inscription to fill a whole book, one will suddenly come across what at first appears to be quite a different inscription altogether but which, on closer examination, turns out to be *Huwa'l-Baqi* in yet another form. And when one is quite sure that no further variation is possible one encounter it in the form of a *muthanna*, an intricate form of writing that can be read from both left and right. And when you have finally decided that now indeed nothing further could possibly be expected there appears a *Huwa'l-Baqi* in the *keşide* style, in which the letters are elongated without in any way impairing their intrinsic form or aesthetic appearance. When I visit these cemeteries with my students they are always amazed at the apparently infinite number of variations that can be applied to the same short phrase.

The tomb of Osman Ghazi.

Today we've climbed and scrambled up and down through every nook and cranny of the Eyüp Sultan cemetery and I think we now deserve a cup of tea. Let's sit in the cafe here and enjoy it.

Old people gather round us pointing to the cameras, notebooks and rolls of paper piled up on our table. "What are these?" they ask. "What are you doing? Do you know to read them? Foreigners are always coming here taking photographs. Why don't you help them? Our people are very unhelpful. They never help them." Then, after tea and a bit of conversation, we decide on a programme for another cemetery.

The appointed day arrives and we make to another graveyard. We know from experience that we have very good hopes of encountering something quite new and unusual, although we also know that we shall be saddened and depressed by the neglect and dilapidation that we are sure to find amidst all this beauty. Our only consolation is the thought that some day something may be done about it. While talking or thinking about such subjects we will suddenly come across a very special kind of *Huwa'l-Baqi* that we have never seen before. We feel as if we had discovered a treasure trove.

Tombstones are immensely important as far as our national culture is concerned. Their examination will ultimately reveal extremely valuable and useful information about the Turkish people, and their culture and history.

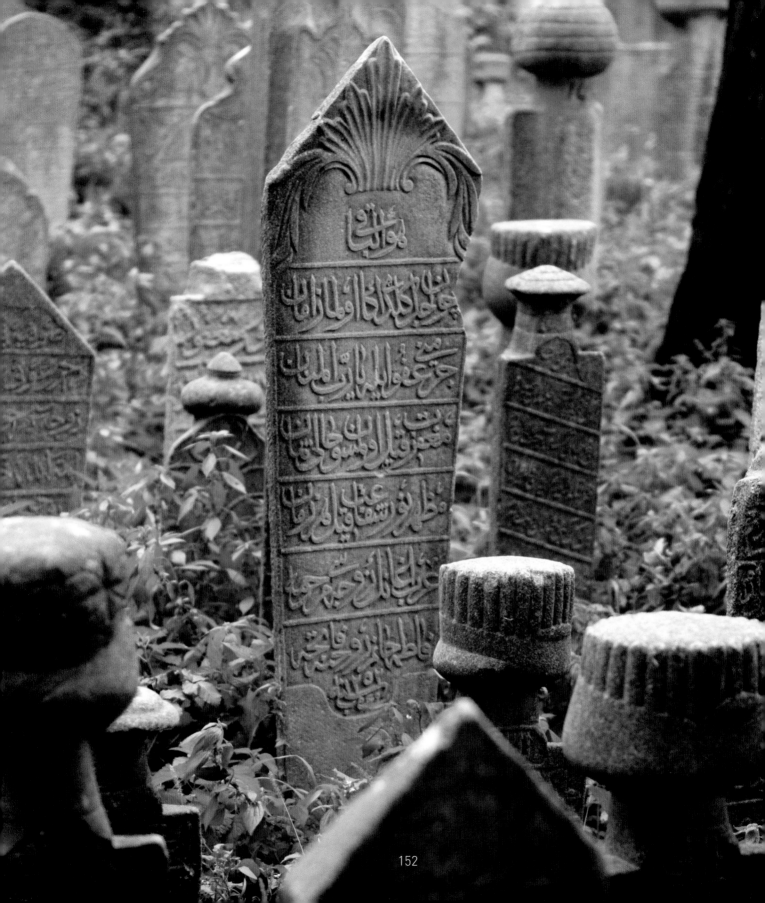

Ottoman tombstones can be classified as follows

1. Historical importance

Centuries

Periods

Seljuks
(12th and 13th century)

Beyliks
(14th century)

Ottomans
(14th 15th 16th 17th 18th 19th and 20th centuries)

The Tombstones
of Statesmen

The Tombstones of Ordinary Man
Woman
Child

The Tombstones of Religious Orders
Mawlawi
Qadiri
Naqshi
Rufai
Halwati
Bektashi
Uşşaki
etc.

Academics' Tombstones
- Shaykh al-Islam
- Judge of the Army
- Professor
- Mufti
- *Qadi* (Judge)
- etc.

Military Personnel's Tombstones

Bureaucrats' Tombstones

After the Nizam-ı Cedid Army
- Governor
- County Governor
- The Members of the Nizam-ı Cedid Army

Before the Nizam-ı Cedid (the New Order) Army
- Viziers
- Rulers (Governor General, Sanjak Chief)
- Sultan's Household Troops (Janissaries) (Yeniçeriler)

2. Literary Merit

Qur'anic Verse

Prophetic Tradition

Maxim

Prose

Poetry

3. Folkloric Value

Heads

Forms

Occupations

Traditions

4. Artistic Value

Calligraphy
- *Jeli Thuluth*
- *Jeli Taliq*
- *Jeli Riq'a*
- Other styles

Ornament
- *Rumi*
- *Hatai*
- *Handasi*

Other forms
- Rose
- Clove
- Tulip
- Cypress
- Cyclamen
- Pomegranate
- Other flowers and fruits

The art in the wallet

Ottoman Visiting Cards

It is a well-known fact that nations normally combine their own native art and culture with the arts and cultures of other nations, to produce a completely new and original form of art in harmony with their own intrinsic character. But such a process succeeds only when the external influences are divested of their alien character and are fused together with the native tradition to form a new synthesis.

We Turks have borrowed a great deal, both from the cultures of the East, to which, by origin, we belong, and, in recent centuries, from the cultures of the West, and all of this we have adapted to our own character and requirements, melting it and mixing it in our own melting-pot. As an example of something we have borrowed from the West and assimilated in this way we may take the visiting-card, which is referred to in Turkish as a *kartvizit* (deriving, of course, from the French word *carte de visite*).

The Turkish word *kartvizit* has exactly the same significance here as it has in its country of origin, and the object itself is used in much the same way. But our ancestors, who transformed writing into a work of art and invested it with a great variety of forms and compositions, also lent these lovable little objects the most delightful appearance, transforming them into miniature calligraphic compositions. These visiting-cards usually measure about 4.5 x 8 cm, but as they can be used for a great variety of different purposes and the amount of information they have to present varies a great deal,

there is also great variation in the actual dimensions, limited only by the fact that they must fit easily into a wallet or pocket-book. As for the inscription, this must contain, at the very least, the name and surname of the person. Apart from the name and surname, however, the inscription may include any titles the person may possess, his occupation or profession, his home and business addresses, the telephone numbers for both those places, etc.

As for the uses to which these little cards are put, there has been little change in this respect since they were first introduced. The only real change has resulted from the increase in importance of the telephone as a means of communication.

To add a little variety to the topic I might begin by giving an example of an original use to which visiting cards were put during the Ottoman period. In the old days it was the custom for higher officials in the government service to remain at home on the first two days of *bayram* to receive visits from their juniors in the service, these visits being returned on the third day of bayram. These junior civil servants would be shown into the *selamlık* (public reception room), where there would be a large oval table, usually made of marble, with a small box in mother-of-pearl or metal inlay. Whoever came to pay a bayram call would place his visiting card in this box. On bayram visits of this kind the visitor would be offered two different kinds of sweet, and these would be served on a tray with three crystal bowls, two bowls for the sweets and one for water, and with one spoon for each of the guests. The guest would take a spoonful of whichever of the two sweets he preferred, and piece the spoon in the water in the third bowl. He would then drink a cup of coffee with his host, and the bayram visit would be at an end. The visit would be returned by the senior official on the third day of bayram, who would then visit all the junior civil servants who had left their visiting-cards in his box. As he had, of course, a very large number of calls to pay, he would merely drive up to the door of the house in his phaeton and send his servant in with his visiting card. (For this description of the custom I am indebted to the journalist and writer Ziyad Ebuzziya, to whom I applied for information.)

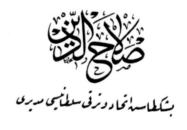

Visiting cards written by Arif Hikmet.

155

The visiting-cards used by various Ottoman state officials, scholars, businessmen and artists were prepared with the most meticulous care by the famous calligraphers of the day.

Arif Hikmet Bey may be mentioned as one of the great calligraphers who did a very considerable amount of work in this field, and the collection of cards belonging to Ziya Aydın Bey included nearly a thousand specimens of his work. But before going on to a more detailed account of Arif Hikmet Bey I should like to mention two other famous calligraphers, Mustafa Halim Özyazıcı and Hamid Aytaç Bey who, besides creating a number of fine calligraphic panels, mosque inscriptions and friezes, also produced a very large number of beautiful visiting-cards.

The date of Arif Hikmet Bey's birth is uncertain. On p. 59 of İbnulemin Mahmud Kemal İnal's book *The Last Calligraphers* we are informed that he migrated from Yugoslavia to Turkey at a very early age, and settled in Edirne. After taking lessons in *thuluth* and *naskh* scripts from the celebrated calligrapher Bakkal Arif Effendi, he was appointed calligrapher to the Matbaa-ı Amire (The Imperial Press), but resigned from this post after only a few years. After this, he took up a series of different posts, his highly temperamental and restless disposition preventing from staying in any one post for any length of time. At one time he opened an office in the Kahramanzade Han in Babıali, where he produced calligraphic panels, embossed visiting cards, seals, stamps, etc. Most of the visiting cards with which we are concerned here date from this period.

Later, he was appointed Director of the Madrasat'ul-Hattatin (School of Calligraphy), which opened in 1914, but he resigned soon afterwards, opening an office in Cağaloğlu where he again embarked on the production of calligraphic panels, visiting cards, seals, stamps, etc. Four years later he died of tuberculosis, at a comparatively early age. He was buried in the graveyard of the Koca Mustafa Pasha Mosque.

An obituary that appeared in the *Tasviri Efkâr* shortly after his death spoke very highly of his work, deploring the fact that his very considerable talents had not been fully appreciated. It also mentioned his invention of a new type of script which he named "Hattı Sümbülî," and declared that his untimely death constituted a very great loss to Turkish calligraphy. At the same time it referred to his rather free and easy disposition.

The visiting-cards produced by Arif Hikmet Bey which I have been able to examine reveal very great and original powers of imagination, coupled with the ability to fashion even the most difficult names into extremely beautiful compositions.

شوكتنا
باغ وصابون نجار نحاسى
ابو اللمع

محمد على
دنب طبيجى

دوقتور
یى جودى

ملازم اول
مصطفى
عثمانلى رومى هاى ة صاديل هند

فارس عبدالله افندى زاده
شيخ جلبى

لطفى
الاشهر الحاج الكريم سعيد رنسى

هيج
ابن

ملازم
اسماعيل حلمى
يكرمى كمجى فوار داسخابات ضابطى

بانغ بيولوغ ـ دوقتور
عثمان اوغوز
فراض داخلیه متخصصى

محمد حمد

قدرى
اسكاره مصرفى

فاطمه سلطان حضرتلرينك مديره امورى
محمد كى

راغى
متقاعد فريق

شهبده موسى باشازاده

فاطمه خانم

ج ـ لامع حقى

دوقتور
توفيق رشدى
بشنجى ارد وحفظ الصحه ميشاورى

اكان حرب بكباشى
فؤاد
شرق اردوارى غروفى ميساورى

مدرس النفوس وعضو هيئة التدريس
كلية آناتورال للتربية جامعة مرمرة
اسانبول تركيا

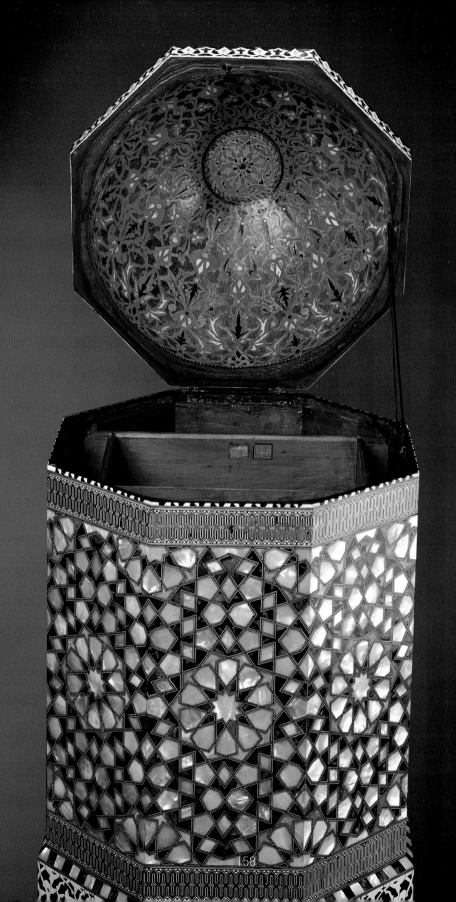

Mother-of-Pearl Inlay

The well-known architects trained in the palace also mastered working with mother-of-pearl, probably because this art is an art of "measure, drawing, and aesthetic." In the 16th and 17th centuries, it was very fashionable to use property made out of mother-of-pearl. Mother-of-pearl was also used in architecture. The tomb of Murad III in the courtyard of Hagia Sophia was inlaid with mother-of-pearl by the famous contractor Dalgıç Ahmed Agha, and the windows and the main door of the Blue mosque were engraved by the well-known architect Mehmet Agha. Evliya Çelebi mentions the engravers during the Murad IV sultanate: "They are 100 shops and 500 soldiers and their master is Shuayb-i Hindi."

The "infatuation with the West" which started in the 18th century has resulted in a lot of harm in the art of working with mother-of-pearl, just as it has harmed other traditional kinds of arts. The enthusiasm for several baseless trends and the cutting of government subsidies pushed this invaluable art into the darkness. At the end of 19th century, we saw two twinkling lights in the valley of mother-of-pearl when everything else was going dark. They were Sultan Abdulhamid II and the engraver Vasıf (Sedef).

Sultan Abdulhamid II, who was also a fine carpenter, produced many elegant works of art in the workroom he designed in the Yıldız Palace. Vasıf was an artisan from Beşiktaş born in 1876. He graduated as a lieutenant from the School of Bahriye's "Carpentry and Engraving" department. In 1912, when he was 36 years old, he retired as a commander and started working on engraving in his workroom in Beşiktaş.

The most perfect masterpiece of "mother-of-pearl inlay" was made by Vasıf Sedef—the doors of the Holy Mantle in Topkapı Palace.

In 1936, a professorial chair was established in Oriental Embroidery at the Fine Arts Academy and Vasıf Sedef became head of the department. Unfortunately, the art was beginning to die out. We no longer recognize the names of famous engravers. It may be because of the sadness he felt about the inefficiency of his professorial chair that he died (1940).

Other than Vasıf Bey, who tried to carry this art to the midst of the 20th century, the artisans of mother-of-pearl brought their last master to the Istanbul Balıklı Armenian Cemetery on

◀ A Qur'an case, in
Istanbul style.

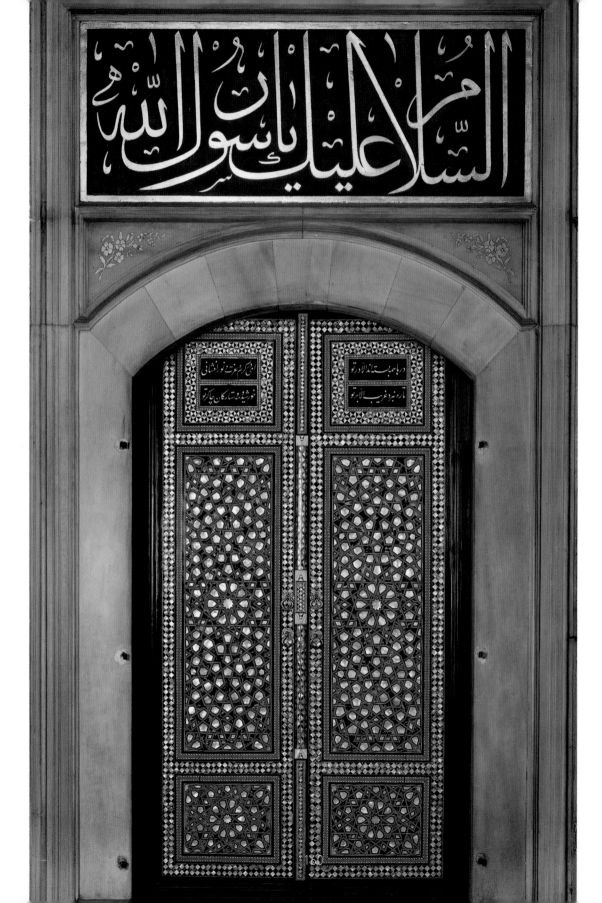

January 19, 1982: Nerses Semercioğlu.

He was born in the Kumkapı District of Istanbul in 1914 and brought up during the war years and faced a lot of hardship during his childhood. Shortly before his death, he wrote an auto-biography. In a nutshell, he wrote: "....I started primary school in 1924 and was able to continue till the 4th grade.

At the end of 1928, I became an apprentice of the Engraver Mihran Agha in the Grand Bazaar. We used to mostly do repairs or simple stools called *serpme* or inlaid stools or inlaid book-rests. We used to sell one big and two little serpme primed stools, which we used to spend one week working on, for 30–35 liras. When we could get our money from the stores, I used to earn 6 liras a week. Otherwise, I would go home many weeks without my weekly salary. My master died either in 1936 or 1937.

At his funeral the neighbors told me, 'Instead of bringing a garland, you should have given his money to his wife; that would be more desirable.' The neighbors had paid for his funeral expenses. May God have mercy on him!"

Master Nerses pointed out that the fortune of his art suffered as it became marketable: "....As Master Vasıf used to do the fine carpentry works on the Holt Mantle doors, he had me do the mother-of-pearl inlay on the doors after measuring the pieces to be worked on. He paid 125 kurush for a piece. Master Nerses was the last professional who brought this art to the beginning of the 1980s. He was able to continue making a living, even as the art became popular in the 1950s."

These mother-of-pearl works were done in three different ways—embedding or inlays; coating; or sealing. Let's give a brief description of these three styles.

A. Embedding or Inlays

The skeleton of the piece is prepared before the mother-of-pearl can be applied. For this kind of work, walnut, oak, and ebony trees are used. The designed pattern is passed

The mother-of-pearl master Vasıf Bey, and the door of the Holy Mantle he made.

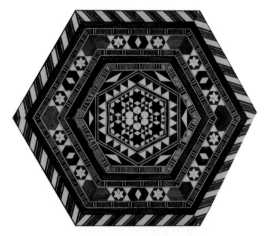

on paper. It is necessary that the paper is either glued on the wood or it is copied on the wood with a steel pencil. Then the places where the inlay materials (ivory, tortoiseshell, bone, or mother-of-pearl) are selected and the selected places are carefully engraved. Mother-of-pearl or other materials are finely cut to fit these places and are glued with hot glue. Rough leveling is done. After the completion of the embedding process, fine leveling is done and the entire work is then polished.

B. Coating

This style consists of coating a massive tree with the desired breed wood veneer. The design is copied on the veneer and the places for the decoration material (mother-of-pearl, tortoiseshell, ivory etc.) is then cleared out.

The most difficult process in this style is refining the raw decoration materials. In this style, there is also an easy way of removing the pattern. Before the coating is glued to the wood, a fine paper is glued. A leveled fine plate of mother-of-pearl is glued on the paper. The purpose of the paper in between is to separate the mother-of-pearl from the coating after the cutting process. A mother paper is glued on the top of the design and the entire work is than cut with a jigsaw. The motifs produced in this way can be applied on the same piece or separately on a different piece.

C. Sealing

This style was actually developed to make use of left-over materials. The tiny mother-of-pearl pieces too small to be used on a backdrop can be placed on various patterns. The spaces in between are filled with paste made out of tree dust and glue. (In the classic mother-of-pearl inlay, only Ottoman glue is used.) When the glue is solid, the rough

Desk and chair, ornamented with mother-of-pearl in Damascus style.

and fine leveling is done with a sanding block. The leveling process continues until the mother-of-pearl finally appears. The work is completed after it is polished in its entirety. This style is mostly used for "serpme" tripods.

The crafting of mother-of-pearl can be divided into four different categories in terms of motif features and areas of use. The first two categories have Ottoman characteristics.

Jerusalem-style mother-of-pearl.

1. The Works of Istanbul, which have been prepared with the embedding and coating techniques, contain supporting elements of ivory, tortoiseshell, and bone. Gold leaf is placed under the tortoise shell. Mother-of-pearl and other materials are specifically used in geometrical shapes in this kind of work.

2. Works of Damascus also carry Ottoman characteristics. Art containing mother-of-pearl was considered Turkish because Syria was a part of the Ottoman State at the time. Works of Damascus are designed with the embedding and inlay styles. They contain "stone of pearls," which is a rough and white pearl. One of the sides would be left rough and the other side would be leveled. The rough side is embedded into the wood. The mother-of-pearl would be framed with lead-tin wires that are 1 millimeter in width and 2 millimeters in depth.

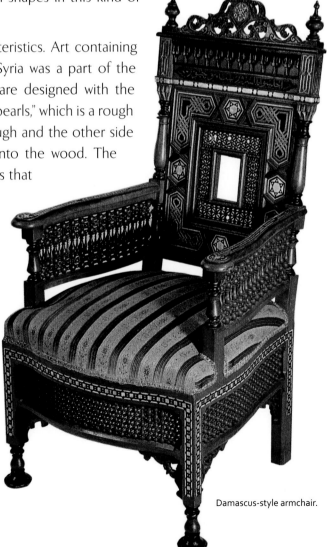

3. Works of Vienna were also called Boule, and used the metal coating technique and were only sporadically made up of mother-of-pearl pieces. It has been characterized by colored mother-of-pearl pieces placed in a disorderly fashion in between mineral fillets. It was usually used on tables, sofas, bedside tables, mirrors, and cupboards.

4. Works of Jerusalem were not usually used in furniture or other small goods. It was used on scale models of mosques (Al-Aqsa Mosque), other models, or plant and animal motifs.

Damascus-style armchair.

What is mother-of-pearl? How can it be used? Mother-of-pearl is in actuality the shells of sea mollusks. These shells are considered to be the symbols of long life and are found on land as fossils. In English they are likened to pearls and called as such (mother-of-pearl). Just like ivory, processed mother-of-pearl is a very expensive and rare material.

The first example of mother-of-pearl works were found in Sumerian tombs. As the raw material of mother-of-pearl is found in warm waters, the inlay probably began in Far East countries such as China, India, or Siam, and was brought to Anatolia by the Middle East Turks.

Unfortunately, we do not have the ancient mother-of-pearl works because it is a very delicate material and it is generally applied on wood. However, we learned from Marco Polo and other Byzantine envoys, who had been in contact with the Turks, that Turks were experts on mother-of-pearl inlay and producing goods decorated with mother-of-pearl.

The first mother-of-pearl inlay of the Ottoman times is found on the doors of the Bayezid Mosque. Later on, the inlay was much improved and wide spread and it was applied from objects as diverse as Qur'an cases to the corners of Sultanate kiosks; from the handles of Janissary beds to inkwell sets of calligraphists; from the quilted turban to clogs. Hodja Saadeddin tells us that Sultan Mehmet the Conqueror's coffin was made out of sterling mother-of-pearl. It is recorded that Topkapı Palace had a mother-of-pearl inlay studio and that they trained engravers. It is known that this studio survived to modern times and that it could still be used for repair works.

Today, we feel the loss of talented mother-of-pearl engravers and admire their immortal works.

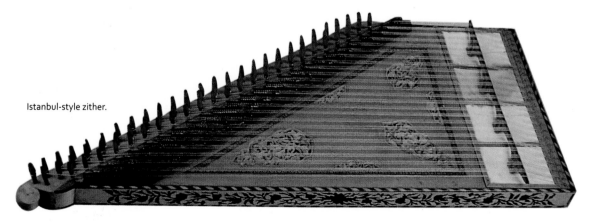

Istanbul-style zither.

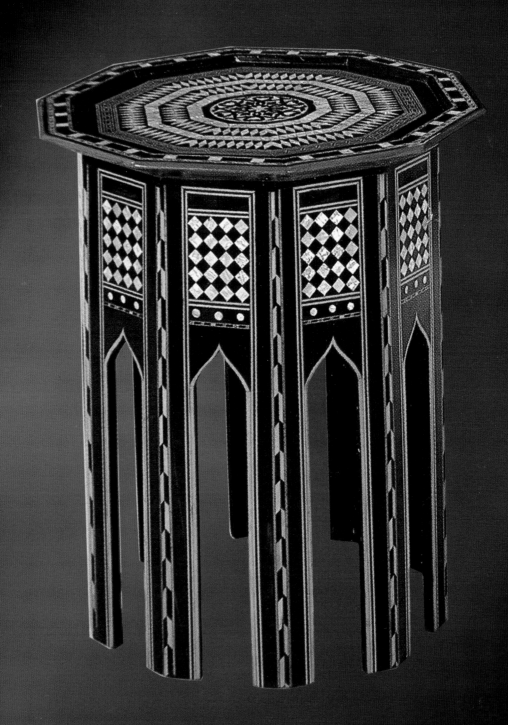

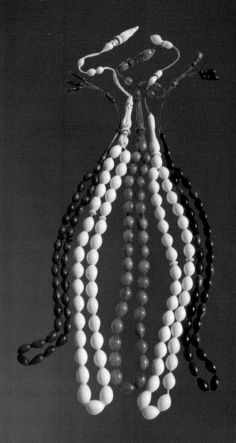

Prayer Beads

In most religions prayer beads are no more than a means employed in the recitation of prayers, but among the Muslim Turks *tesbih* (prayer beads) also forms a branch of the fine arts.

This is true not only for prayer beads. The Turks have adorned everything connected with religion—whether buildings or furniture or utensils—with exquisite taste, and presented them to the world as works of the most remarkable skill and beauty.

In its simplest form the *tesbih* consists of round perforated beads made from a variety of different materials arranged on a string with a thin round disc (*durak*) after every seventh bead. The two ends of the string are joined by means of a bead three or four times the length of the others, known as the *imame*.

The first mention of the *tesbih* occurs in the ninth century, as something introduced into the West from India (A. Mez, *Die Renaissance des Islams*, p. 318). We also learn from the Prophetic saying quoted by Goldziher from Sa'd ibn Abi Waqqas that date seeds and other small stones were at one time used in the recitation of the tasbih and thana prayers.

Although *tesbih*s with ninety-nine beads were customarily used in formal prayer, smaller *tesbih*s with only thirty-three beads were made for carrying around on one's person. On the other hand, the old tekkes (dervish lodges) often possessed *tesbih*s with five hundred or even a thousand beads, the beads sometimes being the size of a walnut. *Tesbih*s such as these were employed to lead the user into a mystical trance.

*Tesbih*s were made from a large variety of materials and were extremely fine j and delicate in appearance. Their use was also a matter of great grace and elegance, with its own forms and | etiquette. A layabout strutting around with his shirt open down to his chest clicking away at a string of beads can't be described as "counting his beads!" In any case, the beads in his hand are most probably the sort of beads known as *sallama*, which are commonly manufactured by prisoners in the prison workshops. (These lie outside the scope of this article, but we should like to say in passing that some of these are also of very great beauty.) A real *tesbih* is not merely an aid to the recitation of prayers. It fills the user with a feeling of pleasure and repose through the elegance and harmony of its beads and, in the case of wooden *tesbih*s, the sweet fragrance it exhales.

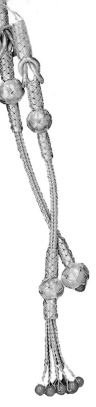

A silver *tesbih* tail with head knots.

As for the materials used in the manufacture of *tesbih*s, these may be divided into three main groups:
a. mineral
b. organic
c. wooden

A *tesbih* itself consists of four sections:
a. *Tane*: Bead.
b. *Durak*: The disc placed after every seventh bead.
c. *İmame*: The long bead joining the two ends of the string.
d. *Kamçı*: The sort of tassel or pendant at the end of the string.
A. Mineral *tesbih*s. These are manufactured from inorganic materials such as agate, amethyst, gold or silver. The hardness of the material makes the manufacture of mineral *tesbih*s a very long and difficult process. Steel or diamond pointed styli or diamond dust may be employed according to the hardness of the material to be worked.

167

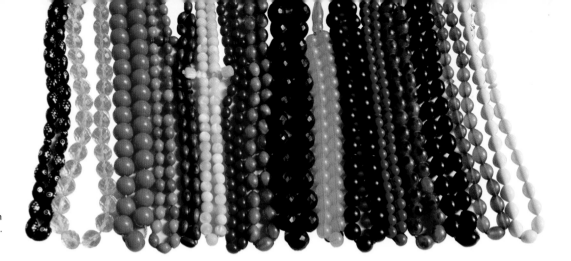

Tesbih samples in various materials.

In the days before the invention of the drill and the lathe it required really incredible skill to perforate the bead and to ensure that each bead was exactly the same size and shape. And now, let me give you very briefly some idea of how a *tesbih* is made. The material to be employed is first of all cut up into pieces of roughly equal size. These pieces are then fixed firmly between the pointed ends of the kemane and molded to the desired shape. The beads may be round, elliptical, semi-elliptical or pear-shaped. The bead is then perforated (the finer the hole the more highly esteemed the work) by a steel instrument made by the craftsman himself (the *tesbih* maker always makes and sharpens his own tools), and finally burnished or polished. After that comes the manufacture of the *durak* discs, which must be perforated exactly in the center. The preparation of the *imame* is extremely difficult. It requires an immense amount of skill to perforate a bead three or four times the length of a normal bead. It can sometimes take three or four years to complete the manufacture of a single *tesbih*. Particular attention is given to making the beads exactly the same size and shape, to the exact matching of the *durak*s and *imame*s, and to the harmony of color. The result of such meticulous and painstaking work is a *tesbih* that merits, and receives, genuine appreciation. Some *tesbih*s are known to have been sold for more than the price of a house.

B) Organic *tesbih*s. These are made of the horns, shells, bones and teeth of both wild and domestic animals. Their manufacture is much easier than that of the mineral *tesbih*s, but great care is still required on account of the fragile and brittle nature of the material. This was cut into strips a little longer than the bead to be made from it, and then these were worked into spheres or prisms of the required size. The *imame*s were measured and cut separately. The craftsman would sit on a very low stool with his knees drawn up to his body and his feet on each side of the lathe.

The *tesbih* was the indispensable attribute of an Istanbul Effendi, who should never be without his beautifully made *tesbih*, his ivory cigarette-holder, his black inlaid tobacco box and his coffee.

He would fix the bead into the lathe and, while turning it with his left hand, would cut the bead into the required shape by means of a Steel knife held in his right hand. *Tesbih*s made from tortoise shell present a particularly beautiful transparent effect.

C) Wooden *tesbih*s. These were made from hard, fragrant, very fine-grained woods. The method of manufacture very closely resembled that used for the organic *tesbih*s, but great care was taken to expose the grain of the wood and to prevent the wood from splitting. These *tesbih*s were usually made on special order. Those made from fragrant woods were stored, when not actually in use, in special metal boxes to preserve the scent. Particularly fine workmanship is displayed in the *durak*s, *imame*s and *kamçı*s of these wooden *tesbih*s.

The distinguishing features of a high quality *tesbih*:
1. The beads are al of exactly the same size.
2. The perforations are very small and conical in shape. A connoisseur in *tesbih*s once said to the famous *tesbih* maker Halil Usta: "If two threads can pass through the hole I shan't accept it!"
3. The *imame* is the length of four ordinary beads.
4. The head section of the *kamçı* is the length of two beads.
5. The perforations are situated in exactly the center of the bead. Connoisseurs of *tesbih*s can immediately tell the maker of a *tesbih* in spite of the fact that these exquisite pieces of work never bear the maker's signature. From among the most famous *tesbih* makers may be mentioned Hasan Usta, nicknamed Horoz (cock), Halil Usta, İsmet Usta of Tophane and Nuri Usta of the Sahaflar, nicknamed Yamalı (patched). Neglected for many years, this craft is now once more arousing interest among the younger generation. We now find young craftsmen like Bülent, the grandson of Yamali Nuri, and Yusuf of Elazığ, alongside middle-aged craftsmen such as Ahmet Düzgünman and Niyazi Sayın, a Turkish ney flautist and music educator.

Of course it will require great effort on their part to reach the standards of the old craftsmen, but this will happen eventually when there is sufficient demand.

Let me now give a list of the various materials from which *tesbih*s can be manufactured, and the appearance and distinctive features connected with each.

a) Mineral *tesbih*s

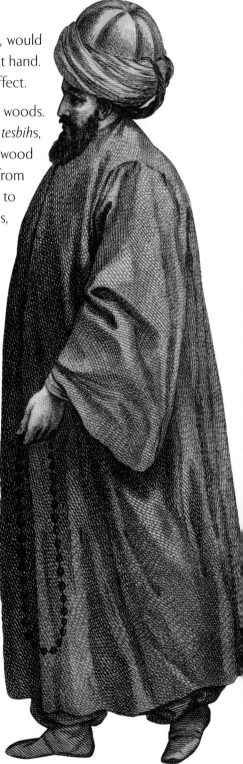

A dervish with *tesbih*.

169

A tail with head knots.

- gold
- silver
- pearl
- agates of various colors

The favored color is red. The different types of agates are given names such as akik-i yemeni or akik-i seylan. Turks look upon it as a sacred stone.

- Hematite: A stone dark olive in color with red veins.
- Amber: A lemon-yellow stone that sometimes displays reddish shades, like fire-amber.
- Jade: A pale green stone.
- Şah Maksut: A green colored stone.
- Aventurine: A stone with yellow spots on a brown ground.
- Embossed silver on black Erzurum stone or wood.
- Rock crystal. This is polygonal in shape and is normally used in the manufacture of *tesbih*s for women.

b) Organic *tesbih*s.

- Tortoiseshell: A transparent brown material with yellow spots.
- Ivory: White with a yellowish grain.
- Mother-of-pearl: Mainly white, but with a variety of other colors.
- Rhinoceros horn: A semi-transparent brown and black material.

(*Tesbih*s were made from various land and sea animals, both wild and domestic. The above list is only meant to give some idea of the main materials used.)

c) Wooden *tesbih*s:

- Amber: A fragrant substance, also to be found in black and white.
- Ebony: A very hard, black wood.
- Tamarind: A hard, very dark brown wood.
- Düreydârî: A very fragrant wood.
- Rose wood: A red-colored wood.
- Pterocarpus: A dark, red-colored wood.
- Coconut: A hard brown wood.
- Sandalwood: A very fragrant, extremely hard, light brown wood.
- Balsam: A hard wood with a variety of colors.
- Kelebek, olive, coconut, sandal and other hard fragrant wood.

Sultan Selim III with a pearl *tesbih*. ▶

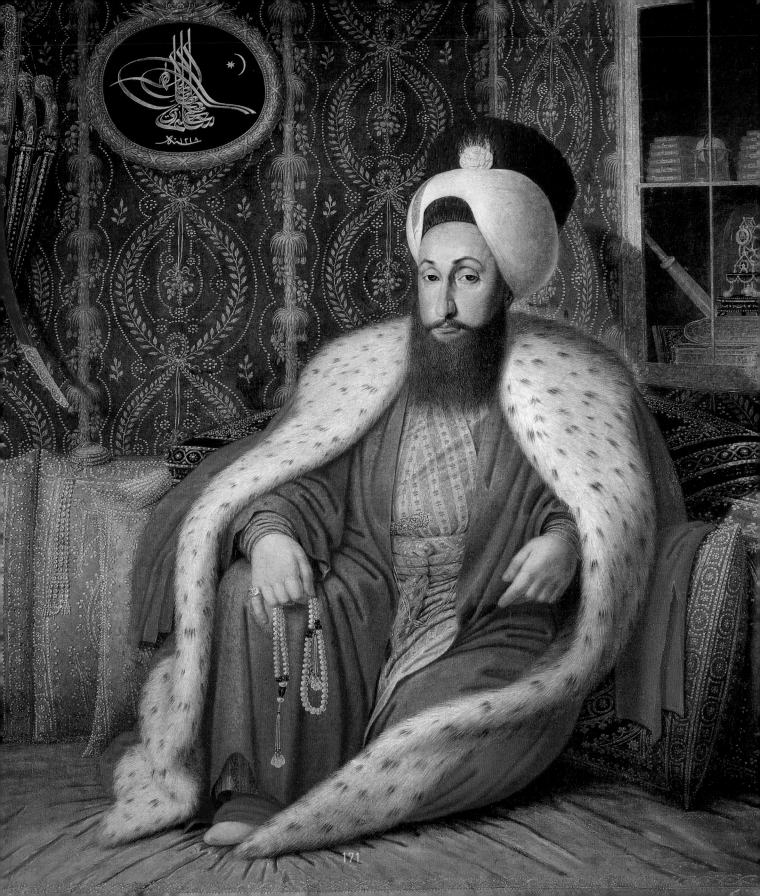

The rosebud of calligraphy

The Signatures of Calligraphers

I wrote this article quite a long time ago, but I added the subtitle a considerable time later. Some people may find this subtitle rather strange, but as a signature is in itself a product of both philosophy and aesthetics I had great difficulty in expressing all I meant to say in a brief subtitle, while at the same time I couldn't rest content with a title that failed to fully express the meaning. That is why I chose the subtitle, "the signature in art, the artistic signature, humility in the signature."

I have no intention of giving a long account of the history of the signature. This can be found in any encyclopedia. The type of signature I have chosen as my topic is the signature to be found in the Turco-Islamic art of calligraphy.

In other words, the calligrapher's signature...

An "ijaza" is a kind of diploma, but differs from an ordinary diploma in not being awarded by an official organization. It is a type of diploma awarded by someone qualified in his own profession to a person he regards as having acquired a certain level of professional skill. The study of the art of calligraphy began in childhood and lasted many years, and until the apprentice had received his ijaza he was not allowed to sign his work. The custom of embarking on the study of calligraphy at a very early age is illustrated by the following conversation between the famous calligrapher Sami Effendi and a neighbor who wished his son to study the art.

"Master," said the neighbor, "I'm going to send our boy to the writing master in the local school to break his hand in. Then I hope you will consent to accept him as your pupil."

The calligrapher Sami Effendi, who knew only too well how difficult it was to correct someone who had learned to hold the pen wrongly, answered jokingly. "For heaven's sake bring your boy to me before he breaks his hand in! How can he possibly learn to write with a broken hand?"

We have just mentioned that students of calligraphy were not allowed to sign their work until they had received their diploma. To sign a piece of work at this early stage would have been regarded as showing lack of respect for their master. Only after having received his ijaza would the student start work on learning to pen a signature. This was just as difficult as learning the art of calligraphy itself, and sometimes took several years. One result of this was that as the

The signature of the calligrapher Mustafa İzzet.

The signature of the calligrapher Necmeddin Okyay.

calligrapher developed, his signature also changed. The difficulty in penning a signature lay not only in creating an object of beauty but also in the creation of a form that contained within itself the whole philosophy of Islam. The signature had to display skill, maturity, seriousness and humility.

Leaving the subject of signatures aside for a moment I'd like to quote a passage showing how the art of calligraphy can be seen through the eyes of a foreigner. The late writer and calligrapher Mahmut Bedreddin Yazır, who produced some very valuable works on the subject of calligraphy, relates the following anecdote in the first volume of the four volume work (only two volumes have been published) *Medeniyet Âleminde Yazı ve İslam Medeniyetinde Kalem Güzeli* (Writing in the Civilized World and Fine Writing in Islamic Civilization).

"During my military service in the First World War, I made the acquaintance of a Hungarian officer and painter. We would visit Istanbul mosques and *madrasa*s together, and examine all sorts of works of art. One day we were standing in the Mosque of Sultanahmet in front of the calligraphic panel "Al kasibu habibullah" (One who conducts business in a Halal fashion is the beloved servant of Allah) written in *jeli taliq* script by Melek Paşazade Ali Haydar Bey. My companion looked at it and then, turning to me, 'My friend,' he said, 'There's something quite extraordinary about your kind of writing. I've noticed that when you first look at it there is just simple color and geometrical stillness. But as you continue to look at it a certain movement becomes perceptible, a certain liveliness, even a kind of coquetry. At first it's just something pleasant to look at. Then it is gradually transformed into a metaphysical music that stirs the soul in silent harmony. There's nothing audible. It can only be heard within, and as one listens one is raised to a more exalted place. I don't know exactly what happens as you look at it. It's like a fascinating countenance, a sea of beauty, a melody that brings peace to the heart with its lovely vibrations. I seem to feel a caress, an embrace as soft and gentle as the breath of an angel. Do you feel the same thing?'"

The signature of the calligrapher Nazif Effendi.

If you permit me I should like to mention another reminiscence told me by my colleague Hasan Kavruk, a very fine painter and educationalist. Seeing me very much absorbed in our own national art he took the opportunity of relating one of his own personal experiences.

"During one of my visits to Europe, I went to see Picasso in his studio in Paris, and I mentioned to him that if he allowed me to work in his studio I should be able to learn a great deal. "Aren't you a Turk?" he asked me. "We are only now trying to achieve in our own art what your calligraphers achieved a long time ago. Go back to your own calligraphy..."

Now, without going off into too much detail, let us return to our subject. Up to the time of the calligrapher Mustafa Rakım (1757–1826) signature were written on the same line and in the same script as the inscription itself with Rakım, the signature acquired a completely new skill and a completely new personality through a combination of *thuluth*, *diwani* and *tawki* scripts.

Such a signature demanded the combination of great skill with maturity of outlook. The composition of the signature, the arrangement of the strokes, its close or wide spacing, had to be balanced and dignified. The writing must be beautifully composed, and each space should be filled by a decorative motif such as a rosebud. The signature should be placed unobtrusively in the lower rows, and should form an organic whole with the rest of the inscription.

In addition to all this, great stress was laid on humility both in the signature and in the meaning. The artist believed that this skill was a gift of God. So if one praised a calligrapher for his skill he would reply, "Thanks to Him who made it possible." Most of our calligraphers would place his signature in the following formula: "... who prays God to forgive his sins" or "This was written by the humble ... hoping for forgiveness."

Some calligraphers, like the very famous Turkish artist Mehmet Şefik Bey and the Toughrakeş (writer of imperial monograms) İsmail Hakkı Bey, sign themselves, "Written by ... pupil of ..."

This shows the great pride pupils took in their teachers, and of course the teachers were also very proud of their pupils.

The calligraphers had a very humble opinion of themselves and would place highly depreciatory epithets in front of their names, such as wretched, lowly, or sinful, and describe themselves as the most insignificant of scribblers, the meanest of writers. Even the Sultans followed that tradition. For example, Sultan Mustafa III, the pupil of Mehmed Esad Yesari, signed himself, "The lowly Mustafa Khan III."

A well-known saying of Sufism runs, "Make yourself nothing and be all."

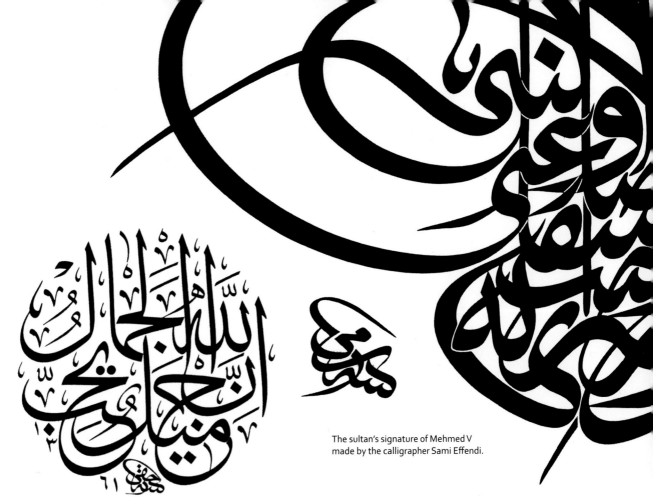

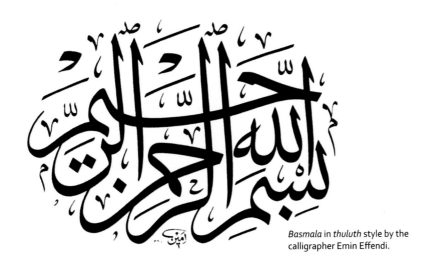

The sultan's signature of Mehmed V made by the calligrapher Sami Effendi.

A layered script in *thuluth* style by the scribe of the imperial monogram İsmail Hakkı Altunbezer.

Basmala in *thuluth* style by the calligrapher Emin Effendi.

How I Wrote This Book

I have utilized two main sources while conducting my research. The first one is the objects and the knowledge and experiences of experts. I have bought most of the materials for each article, scrutinized, and even produced a sample of each of them in 40 years.

The second source is the artists and artisans, who have lived from the last years of the Ottomans to the first years of the Turkish Republic. They learned our traditional arts from their masters, and practiced what they learned. I would like to mention my teachers and friends, most of whom have already passed away, with respect and gratitude:

Uğur Derman (calligraphy historian)
İbrahim Asil (filigree artist, jeweler)
Sait Asil (silver antiquarian)
Hilmi Aşar (jewelry artist)
Emin Barın (calligrapher, bookbinder)
Mustafa Bozdoğan (wall-decorator, coppersmith)
Ziyad Ebuzziya (journalist, writer)
Rikkat Kunt (academic, ceramist, illuminator)
Kirkor İnceyan (silver marquetry artisan)
Mehmet Ali Özdeli (kilim weaving artisan, observer, man of the people)
Muharrem Özsulu (jewelry artist)
Burhan Öztop (silversmith, artist)
Nebih Okyay (colonel, scroll saw artisan)
Salman Poyraz (coppersmith, the man who knows copper works the best in Turkey)
Şevket Rado (historian, researcher, writer)
Nerses Semercioğlu (mother-of-pearl master)
Midhat Sertoğlu (historian, researcher, writer)
Ragıp Tuğtekin (artist, singer, calligrapher, Karagöz shadow play master and director)
Süheyl Ünver (medical doctor, artist, illuminator, researcher),
Mustafa Düzgünman (marbling artist)